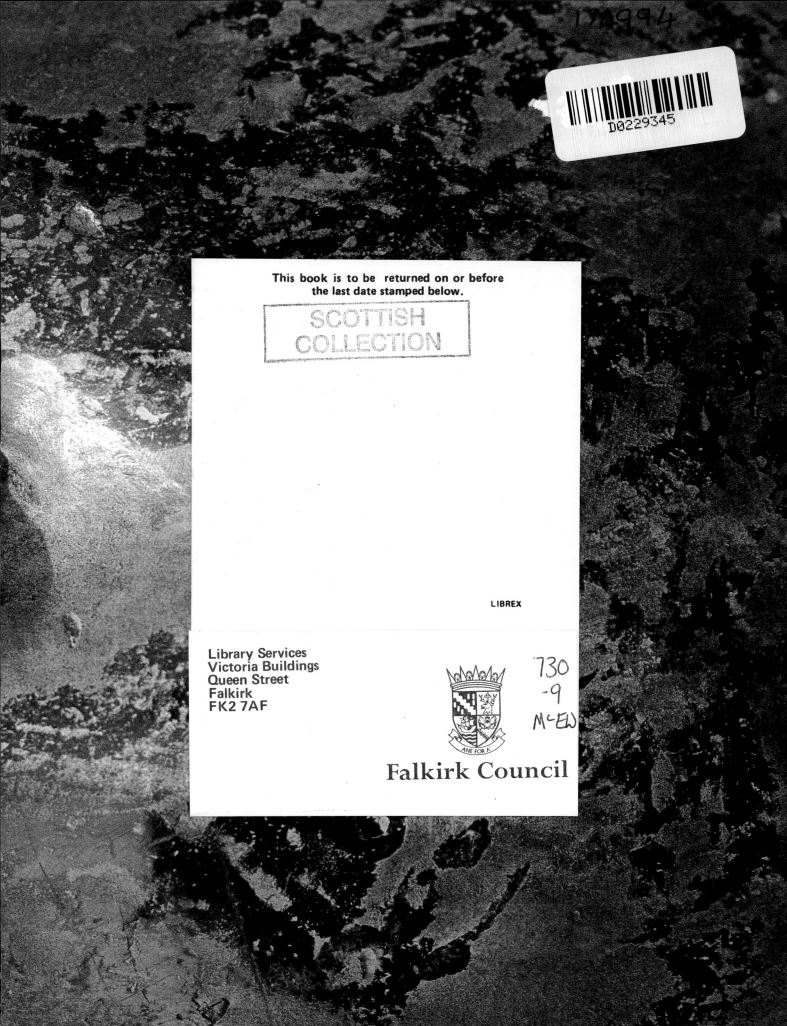

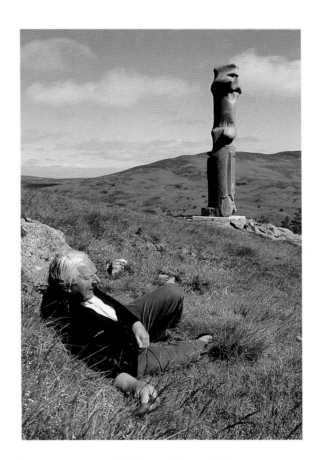

In memory of Tony Keswick

Glenkiln

John McEwen

photographs by John Haddington

Canongate Press

Glenkiln and its sculptures are the
property of Henry Keswick Esq.

First published in Great Britain
in 1993 by Canongate Press plc
14 Frederick Street, Edinburgh EH2 2HB
Text © John McEwen 1993
Photographs © John Haddington 1993
Designed by Dalrymple
Printed by BAS Printers, Over Wallop

British Library Cataloguing-in-Publication Data
A catalogue record for this book is available
on request from the British Library.
ISBN 0 86241 324 9

We should like to thank Henry Keswick;
Mary Moore for making some crucial additions
and amendments to the text, and for extending
its scope by generously introducing it with some
of her personal memories; Amabel Lindsay, for
permission to use the photograph of Henry
Moore; David Brown for reading the typescript;
and the Moore Foundation for editorial and
financial support.

Henry Moore

foreword

When Johnnie McEwen told me that he and John Haddington were working on a book about Glenkiln, and asked if I would like to write a few words for it, I was delighted. But what follows is not a preface in the sense that it either serves to explain the purpose of the book or to justify it; the photographs which appear in the following pages do all of that and more. It is, rather, a happy opportunity for me to record my own memories of a very important and fruitful friendship, a friendship which, while I was growing up, I had witnessed as a fact of life.

I should like to mention another important association, that between my father and Tony and 'K' Clark. 'K' was even a collector while at Winchester and I know that his collection made an impression on Tony. For my father's part, I know that his own friendship with 'K' was very important to him. What all three of these men shared was a place in time; they straddled two ages; they were exposed at first hand to the very vital and influential period of Surrealism. They were aware of art before art became a commodity.

I was a small child when Tony made his first visits to my father. Tony's visits to Hoglands usually took place at the weekend, a Saturday or Sunday morning. For my father, the weekends afforded a different work routine from weekdays; with no secretary, no sculpture

assistants, these were the days he set aside to work in the studio, watch sport on Saturday afternoon television, and for photography. He worked very hard on photographing his own sculpture, and his photographs of sculpture are some of the best I know in that they convey the three-dimensionality of form, presence and, most importantly, an extraordinary sense of scale. Henry Moore was meticulous in ensuring that the line of sight was never destroyed by some intrusion in the background, so that I am sure that over the years Tony's own innate sense of site – as the text recalls: 'the "cuts" of the land, as Tony called them, had to reinforce the sculptural line, not to lose or disrupt it' – was sharpened and enhanced by these photography sessions and his contact with my father. Tony inevitably interrupted and witnessed these sessions, probably even helped.

Over the years, I became aware of the deep affection and respect that both men had for each other. Physically contrasting in size – my father stocky, Tony very big – they were both warm and direct, the kind of people you immediately liked for their human quality. They also had tremendous feelings for landscape and, more importantly, Tony's innate sense of the sculptural responded to Henry Moore, the consummate sculptor. There was unexpected chemistry between the two of them, and their meeting and collaboration resulted in a unique achievement – Glenkiln. Glenkiln will, I hope, stand as an example for all time of how sculpture should be seen in a natural setting. The images of Henry Moore's sculpture at Glenkiln are indelibly printed in the mind's eye.

Mary Moore *Compton Valence, February 1993*

preface

As a child I often saw the modern sculpture collection at Glenkiln. The estate then belonged to my Uncle Tony (Sir William) Keswick, and perhaps I saw it too often since it was not until 1983, when I had been in the art world nearly twenty years, that the scale and originality of his achievement really struck home.

By that time, one had got used to modern artists taking to the wilds. Land Art had been a fashion in the 1960s; and in the 1980s, sculpture parks were a continuing trend; in fact, the list of artists working with nature or having their work exhibited in natural surroundings spanned the globe. But there was still no place where the selection was bolder, or the sitings done with more imagination than at Glenkiln. No place, that is, where sculpture was more enhanced by a natural setting; or, in Tony's better description, more 'possessed its surroundings'. And he had begun doing this in 1951. He was the first.

Ah, the academics may say, what about Edward James? Or the first outdoor sculpture exhibition in Battersea Park, London? That was in 1948. Well, the only answer is to suggest that to compare the average sculpture park with Glenkiln is a bit like comparing a trip to the zoo with an African safari. As for Edward James, his most grandiose outdoor exploits came later, and even then they were more in the tradition of eccentric, squirearchical folly-

making. Tony also had this eighteenth-century side to him, and was an aesthete in all he did; but his love of sculpture went deeper, as tangible and all-embracing as any sculptor's.

Tony affected to dismiss the idea that there was anything special in what he had done; but when he was at Glenkiln — as a guest of his son, Henry, in later years — his greatest pleasure was to pay the pieces a daily visit, and if anyone joined him the better pleased he was. He delighted in giving these guided tours, leavened by jokes, punctuated with self-deprecating apologies for his 'speaking nonsense', but always impassioned and instructive. Incidents or comments contributed by his guests added to his fund of stories, ensuring that no two tours were ever the same — like the weather, which is the revelation of Glenkiln and of seeing sculpture in such splendid isolation.

I asked him if anyone had ever interviewed him about Glenkiln. He said, to my surprise though clearly not to his, that no one ever had. This seemed positively irresponsible, and I suggested we put something on record to be offered to the Tate or some other archive of his choice. He was delighted by the idea, to such an extent that at the end of our first session at his English house in the spring of 1984, Tony proposed we go one step further and produce a book. To this end, we asked the help of John Haddington in taking the photographs, which

he began to do that summer under Tony's instruction. The idea developed that, to give Glenkiln its proper due, the book should convey the place in all seasons and as many lights as possible. Glenkiln is close enough to the Gulf Stream to make snow exceptional, and John did not get his snow pictures until 1990, having even then only a few hours before it thawed. Given that the book places Glenkiln on public record, Tony insisted that I should interview Henry Moore himself. I had discounted any idea of such a meeting because of the artist's ill-health; but the Keswicks did not live far from the Moores when they were in the south, and Tony frequently drove over to Much Hadham for tea with his old friend. In May 1984, Henry Moore invited me to come along on one of these visits. He was confined to a chair but managed a short interview on tape, and I subsequently recorded him on two further occasions. He welcomed the book and was delighted with John Haddington's first photographs, particularly the one of the *Standing Figure* taken at night. Sadly, neither he nor Tony Keswick lived to see the book published. But for Tony the fun was in the making of it, and we did enjoy some very happy moments, particularly on peerless spring and summer days at Glenkiln.

Glenkiln was always where his heart was, and like many exiled Scots the older he got the more he was drawn by the 'salmon instinct' to return home. He welcomed any excuse to travel north, always by-passing Carlisle because it 'reeked of Scottish blood'. The sculptures were his never-ending delight, and all the more so because with every year they visibly gave the same pleasure to an increasing number of visitors. 'Silence is what one prizes most in old age', he said one May evening, as we sat on a bench surveying the glade of primulas in his beloved arboretum. I remembered that evening on my first visit to Glenkiln after his death. I had climbed the hill to the walled sanctuary of firs – a circular wind-break for the sheep in wild weather – to view the monument he had raised there in celebration of his married life. The date of his death had been cut in the marble. The only sound was the rasp of sheep grazing.

This book is also intended as a memorial. In the first place it is a record for the benefit – as Tony wished most of all – of students. Second, it is a tribute to Tony: Glenkiln presented primarily through the eyes of its founder, the reader a guest on one of those conducted tours. Additional comments are contributed by Mary Keswick, his devoted companion on so many of these outings, and Jock Murray, the forester at Glenkiln. Jock's pithy comments amused Tony and helped us.

But, more generally, the book is a celebration of the triumph of art over death. Above all, it is a photographic tribute to an inspiring place. John Haddington photographed each piece under Tony's guidance: as he said, 'The approach of taking the photographs at Glenkiln was to try and get them not cut. I tried five places for the *King and Queen*. I think it would be interesting to take a series of photographs without any of them being cut.' The most important aspect of this was that the sculpture had always to be seen from a position that made it fit harmoniously with its background. The 'cuts' of the land, as Tony called

them, had to reinforce the sculptural line, not to lose or disrupt it. In other words, the gaps in the sculpture were never to be filled arbitrarily by the background; they should be left open, half-open or closed according to the level of the viewer. Hence the careful selection of the sites, which allow the viewer to see the sculpture from the maximum number of angles, up and down as well as in the round. Most books treat sculpture like painting, allotting one photograph per piece — but that is not how Tony looked at it. For him, each visit was a voyage of spatial and tactile discovery, and it is this experience that the photographs in this book — combined with Robert Dalrymple's design — seek to express.

Sensual multiplicity is, of course, the chief difference between sculpture and painting, that it can be physically subjected to so many different views and approaches, and can accordingly offer a greater diversity of form and (some would say) expression. It is a more complicated and therefore less popular art; but for some — and Tony was one of them — it is superior to painting. It was Tony's discovery that modern sculpture (especially Henry Moore's) with its conscious natural affinity looks best when closest to nature. A sculpture in a gallery, subjected to all the visual clutter of urbanity, was physically abhorrent to him. 'You can't see it', he would say. 'Sculpture should possess its surroundings.' 'Possession' was the watch-word for him, and he is right, because the magic of

sculpture in possession of its surroundings is that the surroundings also possess the sculpture. To see the *King and Queen* in a summer dawn is a very different experience to seeing it against a winter sunset. To catch the *Standing Figure* in the headlights of a car provides a visual shock unimaginable to anyone who has only viewed it by day. And so with all these sculptures, it is in the landscape that they continually realise their limitless potential. John Haddington has worked for nearly ten years to capture this fluidity in his photographs, enduring midgy summer evenings as well as racing to catch those surprisingly rare hours of winter snow.

'Sculpture should always at first have some obscurities and further meanings. People should want to go on looking and thinking; it should never tell all about itself immediately', wrote Henry Moore. That is surely why he pinned up his own photographs of the Glenkiln pieces in the maquette studio at Hoglands — as a reminder of the sculptural potentials he had already achieved and seen fully exploited. Visitors to The Henry Moore Foundation today can still see those photographs pinned to their boards. It is hoped that this book will serve a similar purpose; goading those who have never been to Glenkiln to go and see for themselves, and preserving something of its magic for those who have been — and come away knowing they will never see sculpture in quite the same way again.

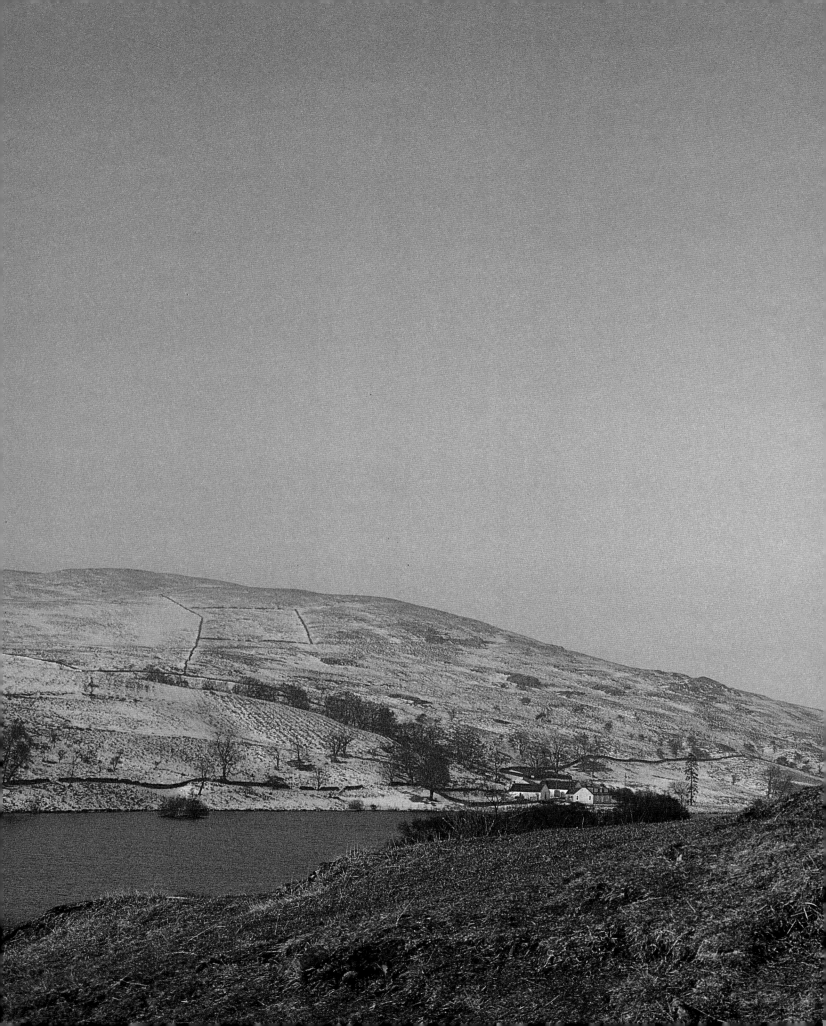

place

Glenkiln lies eight miles due west of Dumfries, off the road to New Galloway and the Solway Coast. It is a hill farm, with undulating fields petering out as the land gathers height and turns into open pasture and rocky moorland.

The road runs like a roller-coaster towards this high ground for a couple of miles, eventually descending into a long corner from which two further roads spur to the left in quick succession. The first of these continues uphill, with a slight glen to the left and rough pasture to the right sweeping to a high and rugged horizon. The first apex of this road is crowned by Henry Moore's *Two Piece Reclining Figure.*

The second road takes a lower-lying route, first though the silence of woods and then along the shore of a reservoir. In a field on the left, overlooking this stretch of water, sits Henry Moore's *King and Queen*, while on the far horizon, half a mile above and beyond it, his *Glenkiln Cross* can just be seen as a crucifix against the sky. At the end of the reservoir, Rodin's *John the Baptist* adorns an outcrop of rock; and if you continue straight ahead for another quarter of a mile, Moore's *Standing Figure* commands a wayside boulder at the next road junction.

The hill between these two roads is crossed by a track, negotiable by car in most weathers but requiring the opening and shutting of several gates to keep in the sheep and cattle. This is the Covenanters' Road, its name deriving from the religious wars of the seventeenth century in which the supporters of the Presbyterian Covenant took to the hills in order to practise their temporarily outlawed form of worship. The Covenanters were persecuted with particular zeal in Galloway, and many of the physical features of the district's deserted moorland countryside, not least the stones which marked their meeting grounds or coventicles (many of them now scandalously lost in the newly planted conifer forests of the Forestry Commission) are romantically enshrined as patriotic symbols of Scottish resistance to English rule.

This old track lends its own myth to the romantic spirit of Glenkiln, a myth embellished, as one travels along from east to west, by the *King and Queen*; a memorial stone to Henry Moore; Epstein's statue of the *Visitation*, in a clump of pine trees below the road; a stone, in a distant clump of pines up the hill, commemorating the marriage of Tony and Mary Keswick; and in a field, an isolated stone gate-post bearing an inscription to the memory of the Keswicks' great friend, Peter Fleming, writer and brother of Ian Fleming, creator of James Bond.

There is no law of trespass in Scotland, so all these works placed in the open countryside and in easy reach of the road can be visited by the public. Only the *Glenkiln Cross* requires a walk to be seen in detail.

beginnings

Tony Keswick was given the 3,000-acre estate by his father in 1924 as a twenty-first birthday present, but work prevented him from paying it more than fleeting visits until business brought him back to London after the war. The intervening years had seen him mostly in the Far East, engaged with his family's firm of Jardine Matheson, the Hong Kong trading company, of which he was already Taipan (or Chairman) in his twenties. Later he survived an assassin's bullets as mayor of Shanghai — 'The last time I made a speech I was shot . . .' brought the house down at his eightieth birthday lunch fifty years later — before returning to Europe to serve in the war. By 1945, he had reached the rank of Brigadier, Staff Duties, 21 Army Group, in which capacity he helped lay the foundations of the European post-war banking system.

Clearly there had been little time for the appreciation of art, although he remembered the great avenue of statuary leading to the tombs of the Ming Emperors outside old Peking (Beijing), a spectacle which showed the beauty of sculpture viewable against the sky and the importance of being able to see the back as well as the front of the design. He insisted these aesthetic lessons had no conscious effect, but he did subsequently place a marble Buddha at the end of an avenue of Paulonia trees in his Shanghai garden, the Buddha hav-

ing the intended result of making the avenue look longer than it actually was. This may be counted as his first experiment in placing sculpture, even if (in his opinion) it had no direct bearing on his later initiative at Glenkiln.

At Glenkiln, the inspiration was the roadside boulder, the most dramatic of its kind on the estate. Tony thought it called for decoration in the same way as a bare table might call for an ornament. But what? One day, probably in 1950 — all dates to do with the purchase and installation of the Glenkiln sculptures are charmingly undocumented — he drove over from his weekend retreat at Theydon Bois to visit Moore at Perry Green, Much Hadham. By that time he had already begun to collect contemporary art, mostly from the Leicester Galleries in Leicester Square, and it was through this gallery that he had a correspondence with Walter Sickert on the subject of commissioning a portrait. He knew exactly what he wanted — his wife and their four children spiritedly engaged in flying a kite. Sickert eventually declined, suggesting that, since Tony knew exactly what he wanted, why didn't he paint the picture himself.

However, the reason he was driving over to Much Hadham was not in search of art, but brass bath-taps. Local enquiries had revealed that there was a man called Moore who worked in bronze and might have something in that line, and it was in the vague hope of finding or ordering the taps that he made his journey. He had never heard of Henry Moore before, which shows the isolation of contemporary art at that date, because Moore already enjoyed an international reputation. In 1946, he had been the first British artist to have a retrospective at the Museum of Modern Art in New York; and in 1948, he had won the international sculptor's prize at the Venice Biennale.

Moore was busy with visitors when Tony arrived but said he would be delighted to see him and suggested he kill the time by taking a stroll. Tony immediately recognised that he had come on a fool's errand; in fact, he was so embarrassed by his mistake that, while delighted to tell the story in later years, he forbade its publication during Henry Moore's lifetime for fear of offending him. But on the day he was too curious to be put off. He put all thought of taps from his mind and waited.

Moore's studio was then in a low barn to one side of Hoglands, his house in the hamlet of Perry Green, and it was on his stroll that Tony saw, and was immediately captivated by, the *Standing Figure*. It was still in its plaster state, but in his mind's eye he saw it as the perfect complement to the flat-topped rock by the roadside at Glenkiln. When he left Hoglands that afternoon he had reserved one of what turned out to be an edition of four bronze casts.

sculptures Henry Moore *Standing Figure*

Standing Figure was the first of the Glenkiln
sculptures. The finished bronze arrived when
Tony Keswick was away, and in his absence
Mr Maxwell, the gamekeeper, took delivery of
the crate. One glance at the content convinced
him it was a spare part for a tractor, so he sent
it up to the farm from where it was later res-

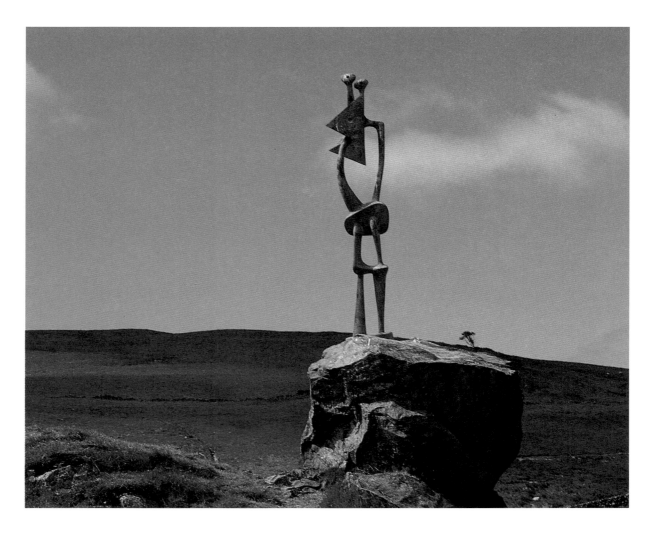

cued. 'Maxie' (as he was known to the family) always referred disparagingly to the piece as 'Yon Figure'; this amused Tony and Moore, so within Glenkiln circles the new title stuck.

Maxie recognised that 'Yon Figure' was the thin end of the wedge, and he rightly guessed that the next best site for a sculpture was the rocky knoll where Rodin's *John the Baptist* now stands. So he planted a fir tree there. It was only on Maxie's retirement that Tony removed the tree and began to look for a sculpture to replace it.

The speed with which Glenkiln captured the public imagination can be gleaned from the fact that even in the 1950s it was already the focus of foreign interest. Once, the director of a German museum wrote asking if he could bring a group of scholars to see the sculptures. Tony replied that since he could not be there to welcome them, the director should notify his 'keeper' at Glenkiln who would show them round. In his answering letter, the director apologised for his ignorance and asked if he could have details of 'the Keeper's' academic record.

Maxwell was not alone in taking a dim view of the sculptures. In the beginning, Kenneth Clark was also very hostile to the idea of Moore's work being placed in the open. Clark was a friend of both men, which makes it all the more surprising that Tony and Moore had never heard of each other before their chance meeting. Tony had known Clark since their school days at Winchester and always dated his interest in contemporary art from his first term there, when Clark showed him an Augustus John drawing. As for Moore, Clark had been his most influential champion in the art world

since the outset of a friendship which had begun in 1938. But when Clark was first shown Glenkiln in the early 1950s, he was appalled by what he saw. When he returned south he advised Moore, behind Keswick's back, that he should on no account have anything further to do with the place.

Clark's chief objection was that one of Moore's finest works – the *King and Queen* was already in place – would be exposed to the damaging effects of a harsh climate where, for most of the time, its only audience would be a flock of sheep. His views were echoed years later by Walter Annenberg, the American collector and Ambassador to the Court of St James. He was more forthright: 'You're an extraordinary feller, Tony. When I buy the arts I keep 'em as near as I can to me and look after them. But the more valuable the things you have the farther away you put 'em, in the middle of the country on top of a hill – so you can't get at 'em: goddammit, you can't even see the darn things!' 'Very nice, don't you think?' was Tony's amused comment after delivering this imitation. It was one of his favourite Glenkiln stories.

Clark soon changed his mind and agreed with Moore that the setting was ideal for his sculpture. His tribute, quoted elsewhere in this book, is eloquent testimony. Perhaps we should also remember that his disapproval had a precedent. Kathleen Sutherland, the wife of Moore's friend and contemporary, the painter Graham Sutherland, remembers early days when Clark complained that the young Henry Moore's work reminded him of 'hot-water bottles'. (Roger Berthoud, *The Life of Henry Moore*, Faber and Faber, 1987, p.157.)

17

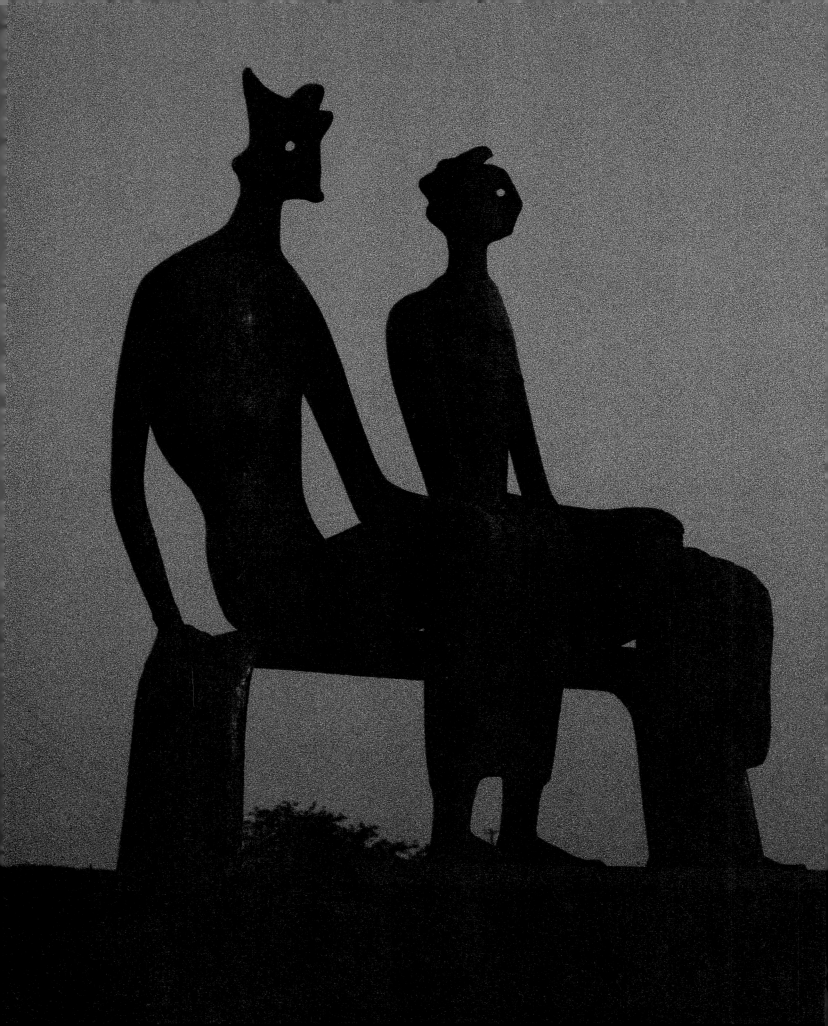

Henry Moore *King and Queen*

The second sculpture to be installed was the piece which, above all, has become the symbol both of Moore and Glenkiln: the *King and Queen*. Today it is regarded as the artist's ultimate masterpiece. There are six (5+1)* bronze casts but the Glenkiln piece is the only one in a private collection. Tony visited Moore several times when he was modelling it. He recalled that the Queen was the first of the two figures to be completed and that initially the seat was solid – a mistake in his stated view, and one which Moore rectified. He also remembers the day Moore asked him to help move the plaster cast of the Queen out of the rain. To his horror the cast broke at the waist, but Moore remained reassuringly unruffled.

Tony said that the piece was named the *King and Queen* because it was made in 1953, the year of Queen Elizabeth II's coronation. Moore had refused a public commission to commemorate the event, but is quoted saying in 1954 that the sculpture was an unconscious result of his reading fairy stories about kings and queens to his daughter, Mary. Whatever the reason, he intended the figures to have an aura of regal authority.

The *King and Queen* was installed at Glenkiln in the summer of 1954. Unlike the *Standing Figure*, Tony tried the piece out in different sites before arriving at a final decision. It was first placed on the upper slope of the sheep-dip field at the western end of the

Covenanters' Road, the same field in which the memorial stone to Peter Fleming now stands. But after it had been there for a couple of days, Tony moved it. As things turned out, the juxtaposition would have been an uncomfortable one – Mary Keswick remembers Peter Fleming always being quite caustic about the sculpture. 'He wasn't a great one for modern art', she explains. Hardly anyone was.

The next site was a ledge of ground a few yards above the sculpture's present position. Here the *King and Queen* was transported by tractor and trailer, and stood for a few hours before being moved down the field. Since its final installation, the local electricity board has run the supply on telegraph poles along the hill behind. Tony specifically requested them not to do this, as the wires cut across the line of vision when the sculpture was viewed from the front; but the board disobligingly refused to redirect them along the road. There are two things Tony wanted to change at Glenkiln: the position of these poles, and the officious road sign which interferes with some views of the *Standing Figure*.

* Henry Moore was offered a large sum of money to make an extra cast of *King and Queen* and asked Tony, as the only private owner among the holders of the first edition, if he had any objection to the increase – the implication being that this would marginally devalue it. Tony said he had, and accordingly assumed that that would be the end of the matter. I do not think he ever knew of Moore's solution, which was to make a new cast but to leave the first edition inviolate by listing it as 5+1, not 6. In his will, Henry Moore stipulated that no casts of his work should be made after his death.

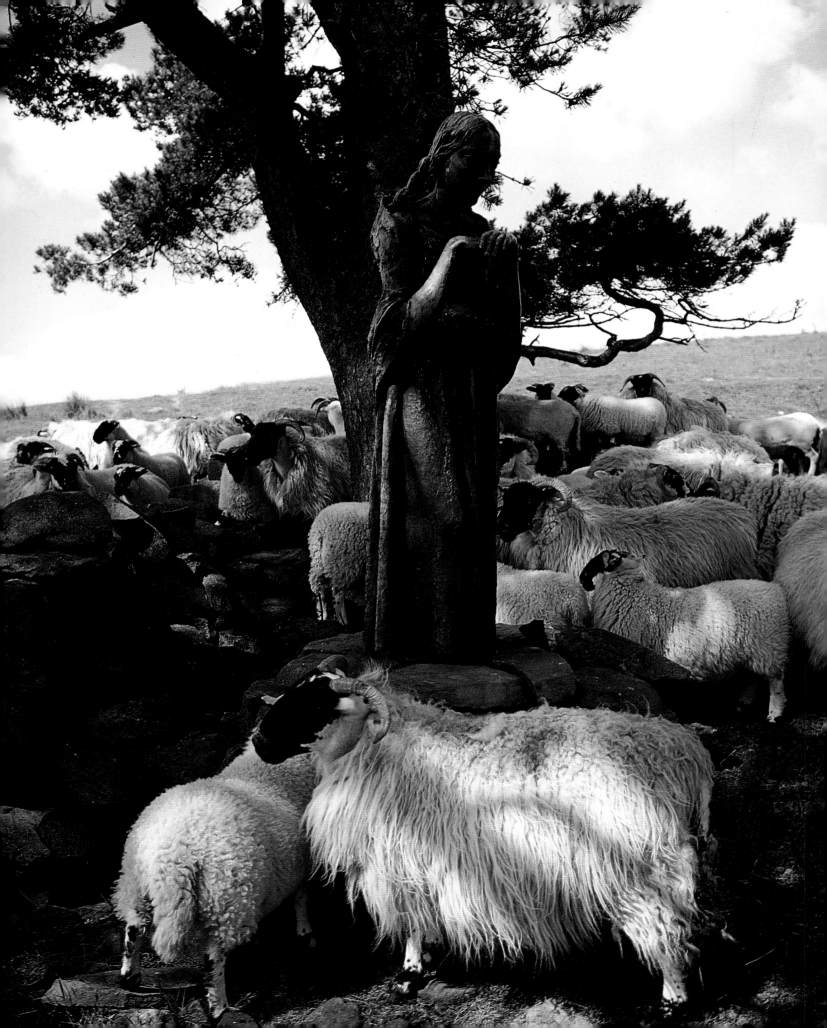

Sir Jacob Epstein *Visitation*

Fast on the heels of the *King and Queen* came Epstein's *Visitation*, a bronze dating from 1926 and one of the artist's earliest masterpieces in this material. Epstein could not have been a more appropriate choice to show alongside Moore, since he was his precursor in the history of modern sculpture in England, and had been of great help at the outset of the younger man's career. He had regularly invited him to the tea parties in Hyde Park Gate, and often dropped in at the Royal College of Art when Moore was teaching there. He bought his work and secured him his first public commission. Later, a professional rivalry developed between the two men and relations soured. 'I've got a moor in Scotland', Tony said at his first meeting with Epstein. 'Not that awful man!' was the sculptor's gruff misinterpretation. But when Epstein died, Moore wrote a heartfelt valedictory in *The Sunday Times*: 'He took the brickbats, he took the insults, he faced the howls of derision with which artists since Rembrandt have learned to become familiar. And as far as sculpture in this century is concerned, he took them first.' ('Jacob Epstein: An Appreciation', *The Sunday Times*, 23 August 1959.)

Tony met Epstein by writing to him or, in his words, 'bouncing him'. On an early visit the proceedings were rudely interrupted by the arrival of three burly men. 'OK guv'nor, where is she?' one asked. 'Under the stairs', said

Epstein, and continued his conversation with Tony. After a while, the commotion caused by the workmen proved too much for Tony's curiosity and he asked Epstein what they were doing. It was explained that they had come to collect a bronze cast of *Visitation* for scrap. At the time, Epstein was working on two portrait busts, one of Winston Churchill, and was apparently so short of money that, despite his age and fame, he was having to sell any bronze he could spare at its scrap value to pay the foundry bills. *Visitation* was in the Tate Gallery collection, so he had decided that his own cast was expendable. Had Tony not stepped in and bought it on the spot, it would have been carted off to be melted down.

Visitation was placed in the open for a short time, but Tony soon decided it needed 'a support', and for several years from 1954 it stood by the side of the reservoir in the more intimate setting of a grove of larches. Despite its relative conservatism compared with the greater abstraction of the Moores, it attracted no less criticism. 'You should see the one he's got now of Mrs Keswick crouching in the bushes', was the response of one local. Tony rented this land from the local water authority for a nominal sum, but after some years he was informed that the lease would be terminated because the sculpture was 'polluting' the reservoir, not directly but through the sightseers it attracted, who had been seen relieving themselves into the nearby waters. Tony's justifiably angry response was to move the piece that same day to a sheep shelter of pine trees, on his own land on the slope below the Covenanters' Road.

It was there that Henry Moore first saw it. Tony and his sons were out for a day's shooting, 'walking up' grouse on the hill, when Moore and his wife visited the sculpture to take photographs. It was misty, and grouse disturbed by the distant shooting party settled in the then heathery ground near *Visitation*, making their characteristic call of 'go back, go back' as they settled. Not knowing anything of grouse, and unable to see because of the mist, the Moores took these calls to be the urgent advice of some invisible well-wisher, and they immediately beat a hasty retreat to the house.

The new site has an even more sympathetic air of sanctuary than the old, and never more so than when the sheep gather within the fold of the trees to huddle around the bowed figure of this gentle mother. Tony deliberately left the enclosing dyke in the tumble-down state in which he found it; and in the springtime the 'Lent lily' daffodils, which so appropriately embellish the ground at the Virgin's feet, seem to have grown by happy accident.

Epstein never visited Glenkiln, but apparently he considered the siting of this piece as the finest for any of his works. Tony's placing of the sculpture was intuitive and done without reference to the artist. All the more remarkable, therefore, to read in Epstein's autobiography that when he made *Visitation* in 1926 he ideally saw it standing 'amongst trees on a knoll'. (*Epstein: an autobiography*, 2nd ed., with an introduction by Richard Buckle, Vista Books, 1963, p.112.)

Auguste Rodin *John the Baptist*

If Epstein is the most appropriate sculptural counterpart to Moore among contemporary sculptors, then Rodin, as the father of modern sculpture, is the perfect complement to both of them. It was Mary Keswick who encouraged her husband to look at Rodin's work. Part of her education had been two months in Paris with her governess, for the sole purpose of sightseeing. The museum she remembered with most pleasure was the Musée Rodin – not so much for the sculpture as the old building itself – and it was at her prompting that Tony visited it on a trip to Paris in the mid-1950s. He was so excited by the collection that he determined to secure a Rodin for Glenkiln, and after long negotiation, he managed to buy a bronze of *John the Baptist* directly from the museum. The price of £2,000 was by far the largest amount he paid for any of the Glenkiln pieces, none of the others having cost him more than £1,000.

John the Baptist, being a man of the wilderness, was an ideal subject to place in the largely uncultivated vastness of Glenkiln, especially at the undammed end of the reservoir, where the figure stands within earshot of a burn, in a landscape of rushes against a backdrop of wild woodland. When burnished by sunlight, the Baptist appears, in Tony Keswick's memorable phrase, to have 'stepped glistening from the waters of the burn', just as he must have emerged from the baptismal waters of the river Jordan.

As Maxie had rightly recognised, the rocky knoll provided the most obvious site for a sculpture on the estate, and its proximity to the road has always made it a favourite spot for a picnic. It is an irony of Glenkiln in general that this most desirable place to see sculpture is most spoilt by the presence of other people. For Tony, animals, because they are a natural part of the place, did not detract from the sculpture – people did. But this was an aesthetic judgement: he was always delighted to find visitors, their enjoyment giving him almost as much pleasure as the sculptures themselves. And visitors there usually are, particularly around the Rodin. I have seen him politely clear *John the Baptist* of half a dozen climbing children, and once he was forced to intervene more forcefully to stop a visitor in the act of scratching his initials on the figure's bronze backside. 'But', was the wide-eyed response, 'other people's done it. Look here.' And the offender pointed to Rodin's signature on the cast.

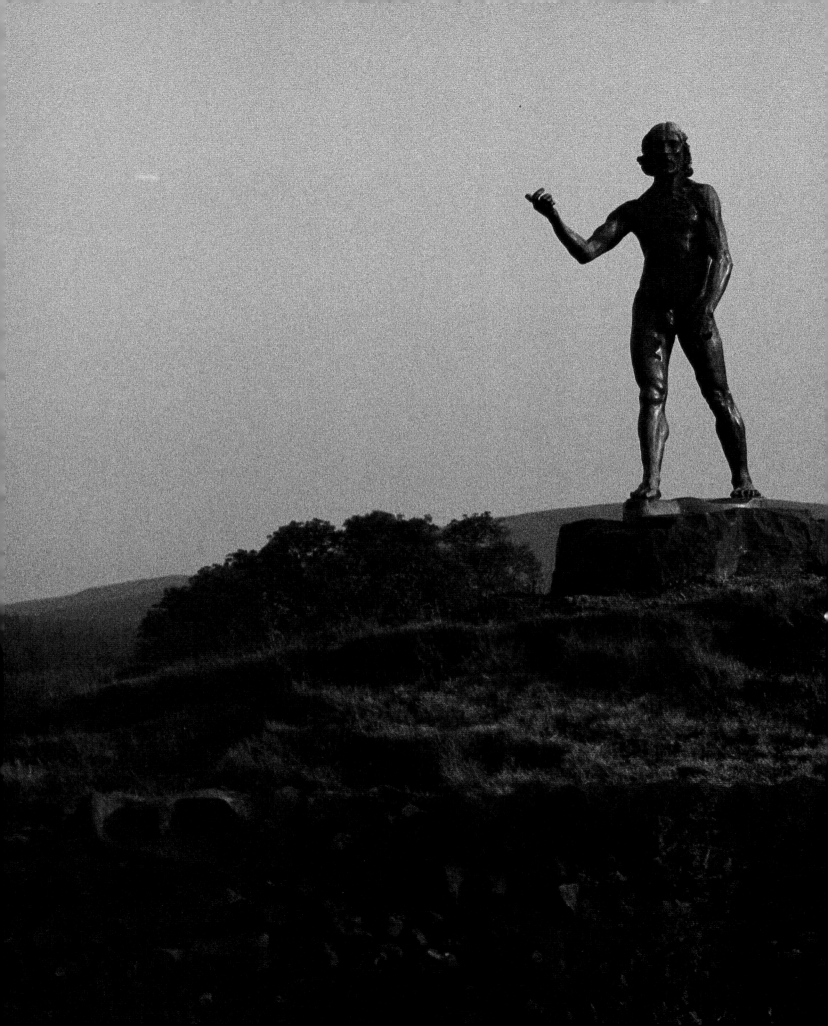

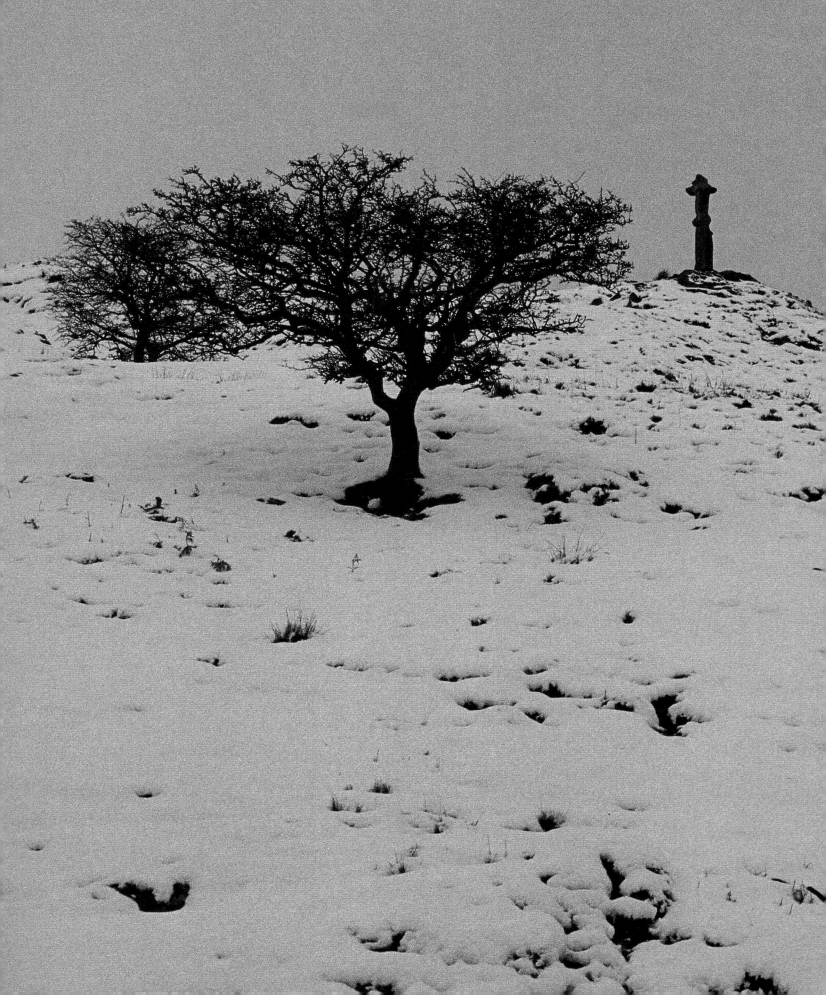

Henry Moore *Glenkiln Cross*

It was while walking back along the reservoir road that leads to *John the Baptist* that Moore and Tony decided on the site for the largest of the Glenkiln pieces, Moore's *Glenkiln Cross*. On the crest of the hill above and beyond the *King and Queen*, the distant figure of a shepherd appeared, counting the sheep on the slopes below. The position he had taken up commanded a view of the whole glen, from the fir plantations beyond the *Standing Figure* to the craggy course of the burn and the 'beautifully modelled' (Moore's phrase) farmlands below the dam. It was clearly the most dominant site for a sculpture, and both Tony and Mary Keswick recalled Moore agreeing to design a piece especially for it. Disappointingly, this is nowhere corroborated by the sculptor. Moore is quoted as saying that the idea for a vertical piece first came to him in 1954, when he was at the Milan headquarters of the Olivetti Company discussing a commission and was struck by the sight of a Lombardy poplar. However, he never doubted the suitability of Glenkiln for the piece and called it the *Glenkiln Cross* accordingly – 'because it is so beautifully sited there'. This was also the name that was always used by him and Herbert Read, his chief critical protagonist.

In the catalogue raisonné of Moore's works, it is known by the less romantic title of *Upright Motive No.1: Glenkiln Cross*, to associate it with and distinguish it from its later companion pieces. There are twelve *Upright Motives*, of which five were enlarged to between six and eleven feet. The *Glenkiln Cross*, along with *No.2* and *No.7*, forms a triptych, one cast of which belongs to the Tate Gallery and is permanently displayed in Battersea Park, London. This triptych is also in the collections of the Amon Carter Museum, Fort Worth, Texas, and the Kröller-Müller Museum, Otterlo, Holland. But the first *Upright Motive* was indisputably conceived as a single work, and its romantic siting at Glenkiln and the unmistakably figurative (even Christian) suggestion of its conception makes a unitary title inappropriate. At Glenkiln, of course, it stands alone – just as the shepherd had done.

Tony remembers Moore having second thoughts while making the piece, particularly with regard to the surface drawing; but eventually he delivered a totemic, cruciform, semifigurative bronze twice the height of a man. Its size and distance from the track made it the most difficult of the Glenkiln pieces to transport and erect. For the last part of its journey in 1956, the sculpture was laid on a makeshift sledge of telegraph poles and drawn by a specially hired caterpillar tractor. They drew the sledge to a point above the selected site and then gingerly slid the piece into its position on a minimal slab of base. As usual, everyone was far too busy to think about taking along a camera. Tony placed it to face due south towards England, so that its outline forms a cross on the horizon when seen from the reservoir road.

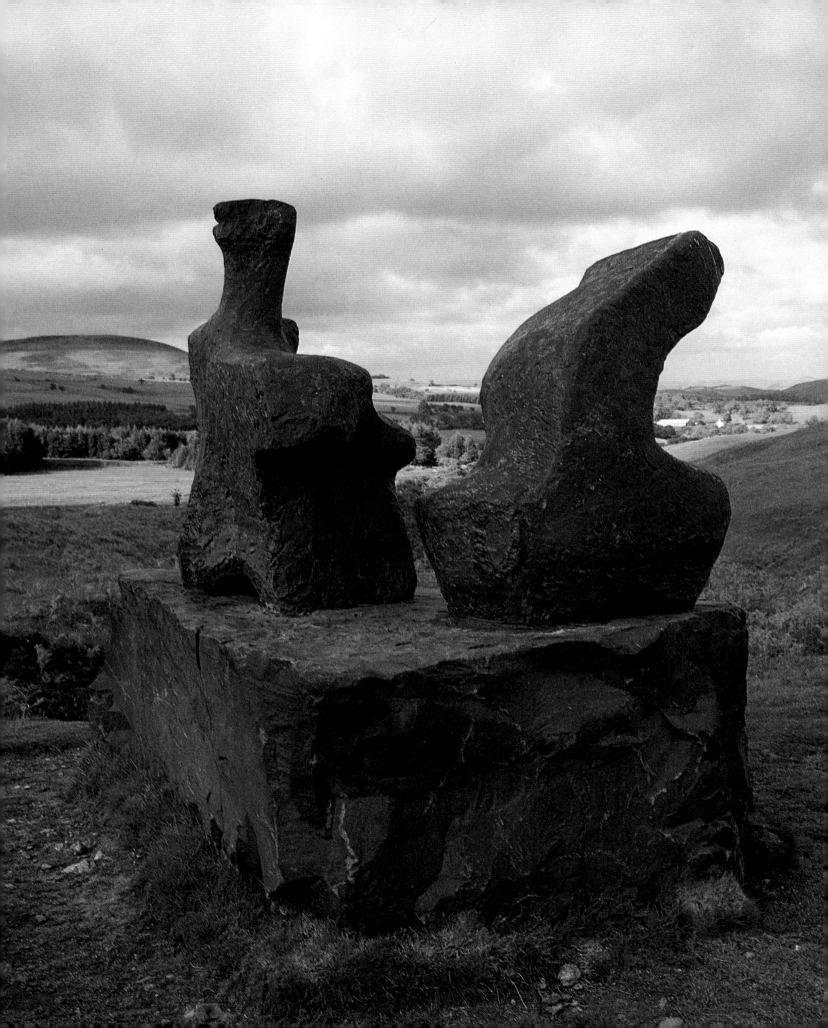

Henry Moore *Two Piece Reclining Figure No.1*

The last of the major sculptures at Glenkiln is Moore's *Two Piece Reclining Figure*. It was lent by Mary Moore, through her father, in 1962 and was first sited by the Covenanters' Road not far from the final position of *Visitation*; but after two years, Tony moved it down the hill to the side of the public road, where it has remained. A gravelly level by the old track still marks the spot where it was originally placed. At first, Tony retained the initial base he had devised, of a platform of shaped but uncemented stones, but eventually he perched the piece on a slab of rock ordered from the local Monington quarry.

After fourteen years the bronze was recalled, a request which necessitated the blasting of the rock. Tony accepted Moore's offer to replace it with the loan of another cast made out of fibreglass impregnated with bronze dust. This replacement does not have the rich patina of a bronze cast, nor does fibreglass reflect the light so vividly, but the colour is much the same and it takes a practised eye to notice the difference. Tony selected an even more massive (ten-ton) rock from Monington for the new base, so massive that when it was lowered into place the crane's automatic alarm sounded and the onlookers took to their heels, fearing that the whole vehicle was going to topple into the glen.

Later, someone scratched the letter 'R' on the surface of the cast. One day Tony was do-ing his tour of the sculptures with a particularly distinguished group of visitors, one of whom was the Queen's uncle, the Duke of Gloucester. When he arrived at the *Two Piece*, Tony pointed out the 'R' and asked facetiously if anyone had any idea as to who might have done it. 'Harry Rosebery?' suggested the Duke. This caused much amusement because a more surreal scene could hardly be imagined than the eminently distinguished Earl of Rosebery passing his time desecrating modern sculpture.

The *Two Piece* is the most abstract of Moore's works at Glenkiln, but highly appropriate to the setting in its rocky derivation. The lower element of the 'figure' has a remarkable similarity to a rock at Adel, near Leeds, which the sculptor first saw when he was about ten years old and always remembered. It also unconsciously echoes the shape of *Le Bec du Hoc* in the 1885 painting by Seurat in the Tate Gallery, which Moore would have seen when it belonged to Kenneth Clark. The front portion of the figure similarly recalls the tunnelled rock of Monet's *Cliff at Etretat* (1883) in the collection of the Metropolitan Museum, New York. This no doubt explains Moore's reference, in conversation with John Hedgecoe, to a non-existent amalgamation of the two paintings: 'Seurat's "Rock at Etretat"'. (*Henry Moore: My Ideas, Inspiration and Life as an Artist*, with photographs by John Hedgecoe, Ebury Press, 1986, p.113.)

Ideally, Tony would have added more pieces to the collection, but only on his own terms. He collected Barbara Hepworth's figurative drawings, for instance, but not her sculpture which he found too abstract.

Two sites he found particularly 'provocative' were the almost perfect hemisphere of a hillock above a glen a few hundred yards along the road from the *Two Piece*, now surmounted by a newly planted tree; and the turfy peninsula which can be seen almost islanded in the reservoir as you pass along the road from the *King and Queen* to *John the Baptist* – an ideal spot, if ever there was one, for one of Moore's famous reclining figures. But by 1960, modern art was beginning to attract investors. The heyday of the small collector was over.

Glenkiln grew into a place of 'pilgrimage' (as Kenneth Clark so rightly called it), while its artistic influence, albeit more pervasive than intended, became global. As Henry Moore said to me: 'Before Glenkiln I think people hadn't thought of putting sculpture with nature but then they began to show open-air sculpture and to organise open-air exhibitions of sculpture.' His chronology is slightly at fault, and he adds a rider that he and Tony may not have been entirely responsible for this development. Nonetheless, it does seem reasonable to argue that no comparable act of private patronage in the twentieth century has had more effect on sculptural evolution. As the first person to exhibit modern art in the open landscape, Tony Keswick unwittingly inspired a host of followers, from practitioners of 'Land Art', creating their works in the wilderness, to collectors like the de Menils in America. Public institutions all over the world now subsidise outdoor sculptural projects and parks. But there will only ever be one Glenkiln.

on sculpture in the landscape

Henry Moore

I first saw Stonehenge in 1922 when as a student I went from London especially to Salisbury and arrived there as it was getting dark. I found a little hotel to stay the night and then, not wanting to wait till morning, I took a taxi out to Stonehenge. It was a clear night with a bright moon – the taxi driver stayed with his cab while I walked alone from the road up to the site, slowly nearing those huge man-built blocks of stone standing out against the night sky. Somehow the moon strangely magnified everything. I was profoundly impressed.

Quoted in *Henry Moore Graphic Work 1972-1974*, Fischer Fine Art Ltd, 1974, p.6.

Sculpture is an art of the open-air. Daylight, sunlight are necessary to it, and for me its best setting and complement is nature. I would rather have a piece of my sculpture put in a landscape, almost any landscape, than in, or on, the most beautiful building I know.

'Notes on Sculpture', in Alan Bowness ed., *Henry Moore: Complete Sculpture 1949-54*, 3rd ed., Lund Humphries, 1986, vol. 2, p.11.

Well, the sculpture became a focus because it was different from anything else around it: and therefore you looked at it. It was like seeing a person for the first time. It should look aright anytime. I have no preference for light or season.

Looking at John Haddington's photographs, 25 November 1984.

Herbert Read

We normally associate monumental sculpture with crowded cities, but if we watch the people passing *King Charles* in Trafalgar Square, or *Gattemalata* in Padua, how few glance up to the familiar figures. A great work of art, however, only yields its essence to an act of contemplation – an act that is impossible in a busy thoroughfare. It has some chance of recognition in a park or garden; but attention is best induced when it stands dramatically isolated in a landscape.

Introduction, in Alan Bowness, op. cit., vol. 2, p.10.

Tony Keswick

If there's one thing to get across in a book on Glenkiln, it's that the sculptures possess their surroundings.

Kenneth Clark

All great works of art should be approached in a spirit of pilgrimage. For this reason the supreme examples of siting Henry Moore's work are Tony Keswick's placements of four pieces on his sheep farm at Glenkiln in Dumfriesshire, Scotland. These placements could not have been achieved by a public body, however enlightened – only by an individual with a deep admiration for Moore's work, a creative imagination, and a large area to explore.

Foreword, in David Finn, *Henry Moore, Sculpture and Environment*, Thames and Hudson, 1977.

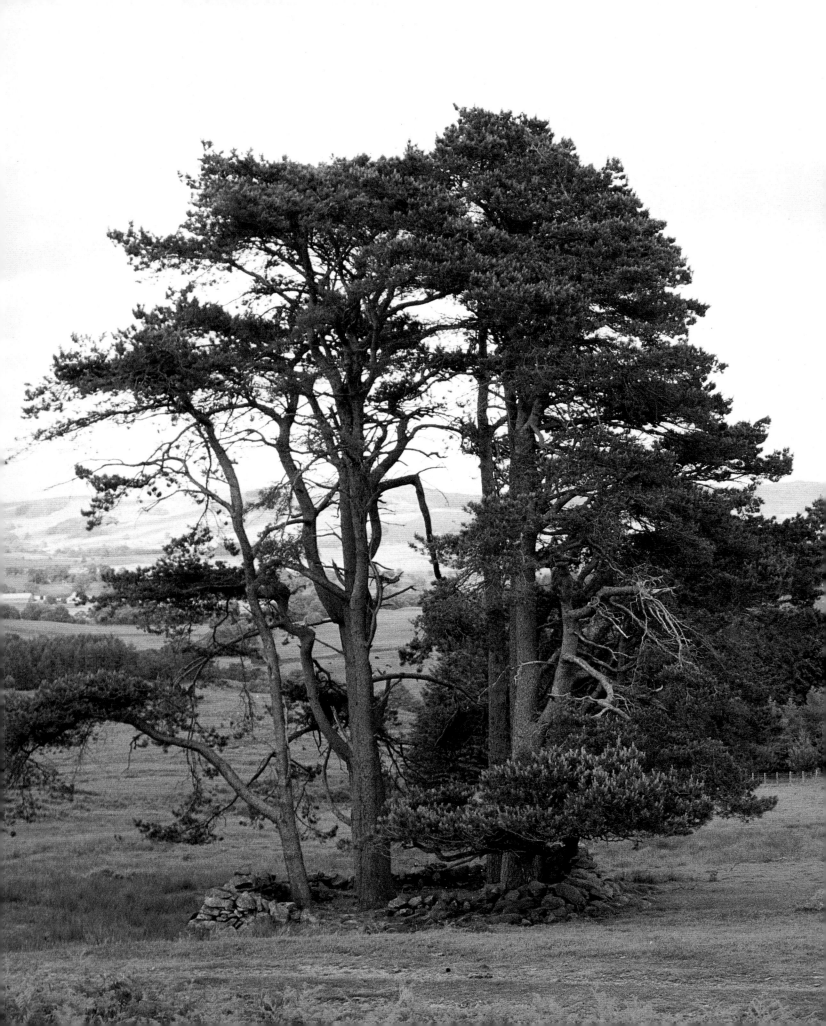

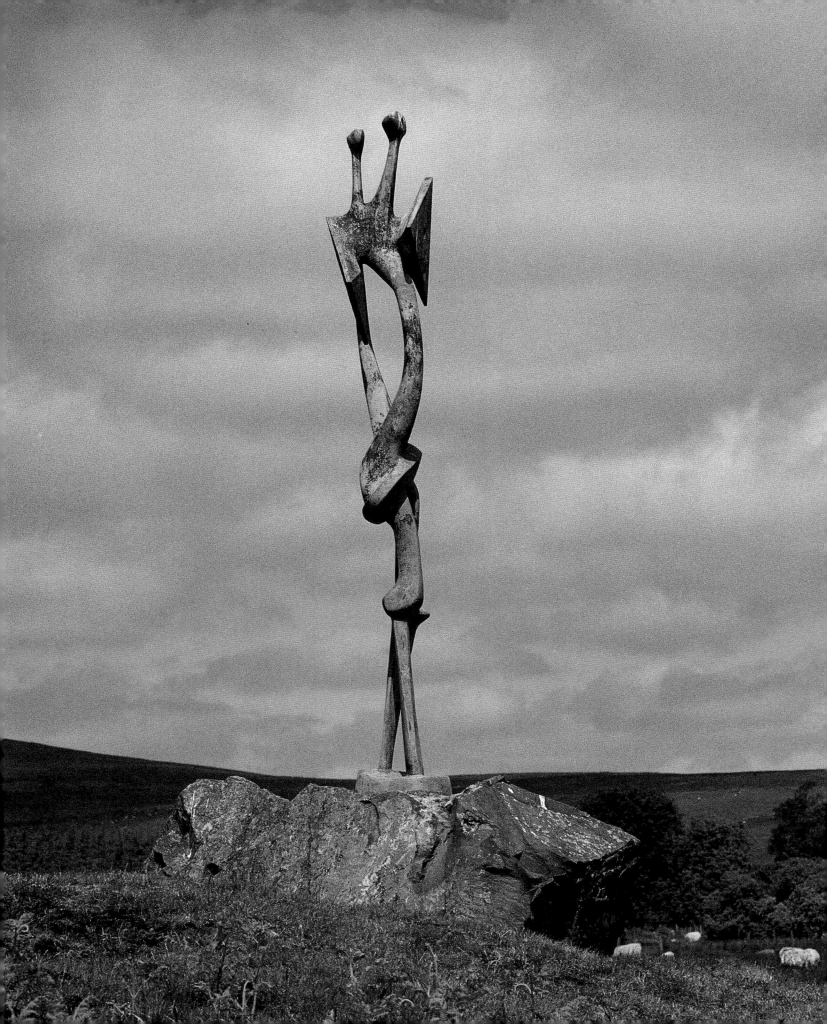

HENRY MOORE 1898–1986

Standing Figure

1950
height: 7ft 3in, 221cm
bronze, edition of 4

Henry Moore

How important to me that Tony Keswick
bought that *Standing Figure* and placed it
there without telling me until he invited me to
see it. The setting is marvellous and so is that
of the *King and Queen* and the *Cross*. All are
placed perfectly. Seeing them has convinced
me that sculpture – at any rate my sculpture –
is best seen in this way and not in a museum.

Henry Moore: Sculptures in Landscape, text by
Stephen Spender, Studio Vista, 1978, p.26.

Generally speaking, sculpture needs a certain
amount of bulk to make it tell in the open
because the vast expanse of the sky has a
diminishing effect, yet in the case of the most
open setting to which any work of mine has
ever been exposed this rule doesn't apply. In
theory, the double figure with its greater bulk
should be more effective in an open setting
than the single figure, but the extreme open-
ness of the Scottish setting for the single figure
has upset whatever preconceptions I had. In
the bleak and lonely setting of a grouse moor
the figure itself becomes an image of loneli-
ness, and on its outcrop of rock, its lean,
skeletonic forms stand out sharp and clear
against the sky, looking as if stripped to the
bone by the winds of several centuries.

'Sculpture in the open air', a talk delivered to
The British Council, 1955.

Tony Keswick

I still think the best placed one is the *Standing Figure*, the first on the rock.

The technical jaw is that every sculpture at Glenkiln is on a slope, so that you can adjust your view of them to suit your height. I don't like the background to cut across the sculpture. If you cut it with a purpose, that's all right; but if it's random, it's no good. I like to see the sculptures against the sky or fitted deliberately to the background. From here, you see, you can get his feet resting on the horizon or by moving lower you can align his bottom with it. That's all right. It's harmonious. You see that green patina? How it blends in with the green of the hill? That's the point of having them outdoors. You can move your height; you can see them from every angle and distance and you can fit them to their background. You can adjust. If you go to a gallery they'll be jammed up against a wall or there'll be people walking up and down or something else to make your eye slide off. Here you can concentrate your eye.

I rather like the cavalry stance it has, as if it's an old cavalryman in his big boots standing at the bar taking it all out on all the other people. And it flows from top to bottom. If you take the right eye and follow that flowing movement down the left side and then cross back through the bottom and down the other leg it's all one stroke. And there's a rather nice fortuitous thing: the triangular face of the rock on this side mirrors the triangle of the 'breast-plate' almost exactly, which is amusing. Its scale is exactly right. It fitted immediately. I think it comes off in this wild place – in snow, dark, rain.

The *Standing Figure* looks wonderful in very bad pouring rain, which often happens. Why is that? It's not 'drawing-room'.

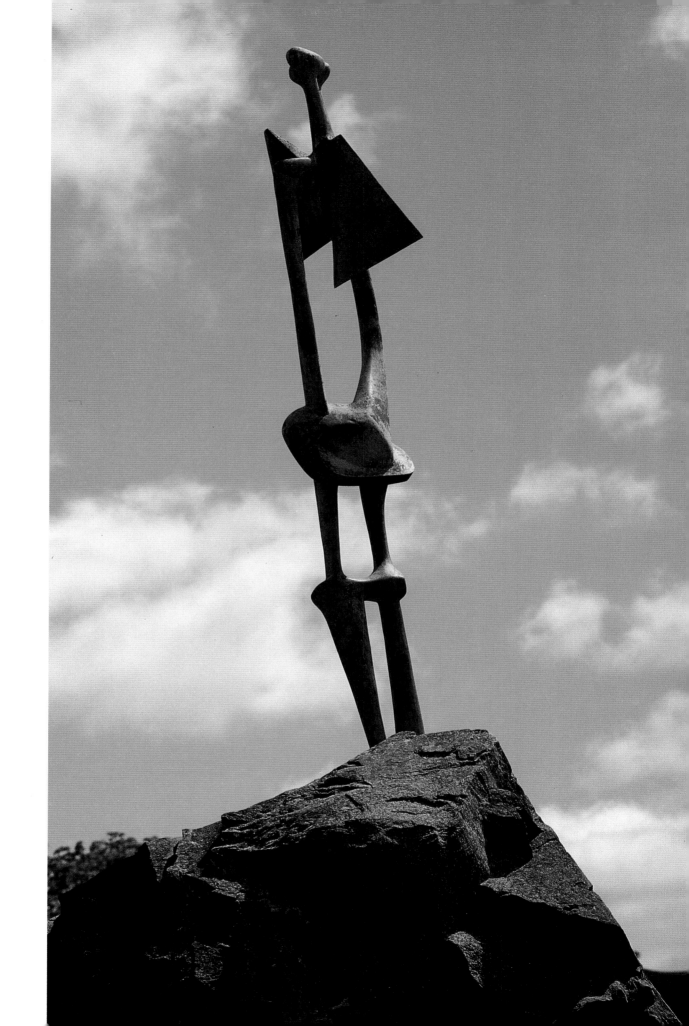

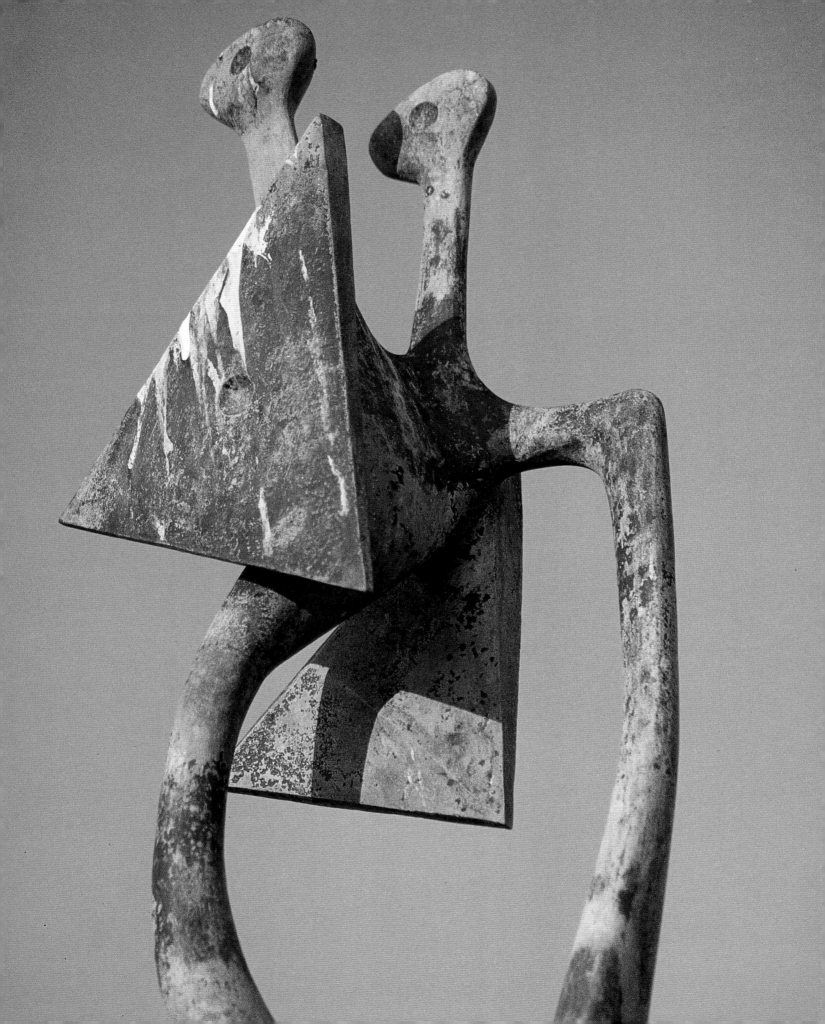

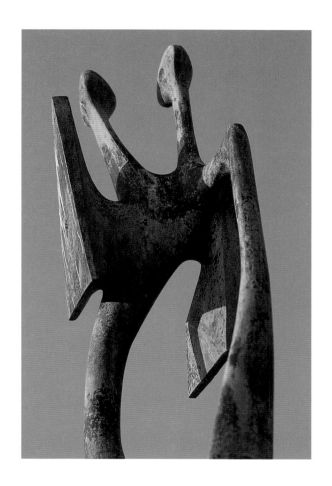

Mary Keswick

I think it grows on you tremendously. I usedn't
to care for it at all, but now I'm very attracted
to it.

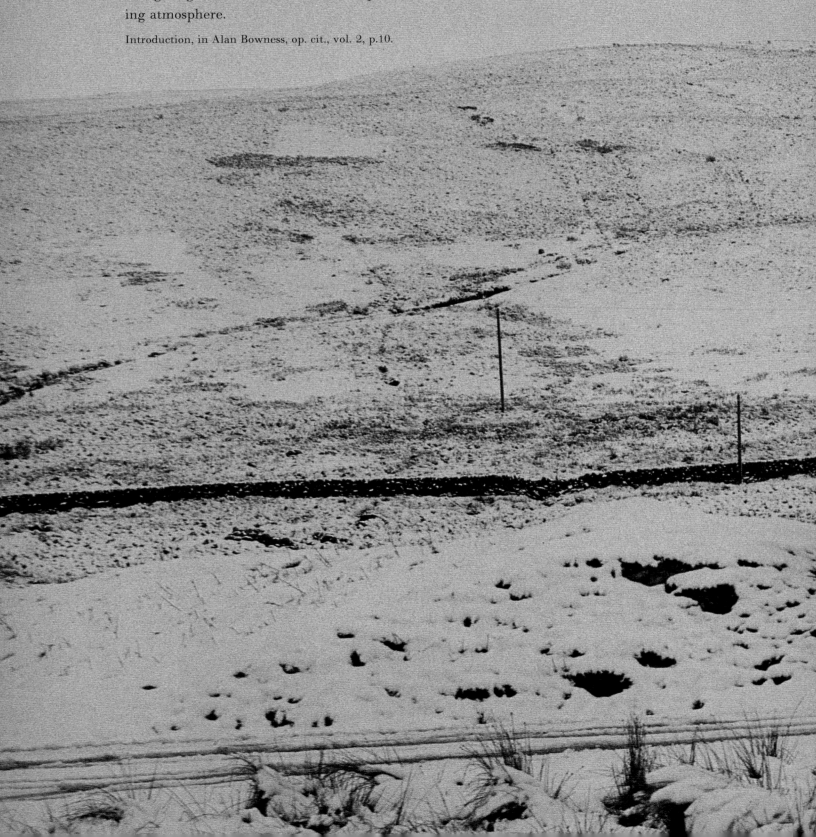

Herbert Read
The gaunt bronze figure – one of Moore's most successful creations during these last five years – emerges from the moorland like some *genius loci*, giving form and definition to the prevailing atmosphere.

Introduction, in Alan Bowness, op. cit., vol. 2, p.10.

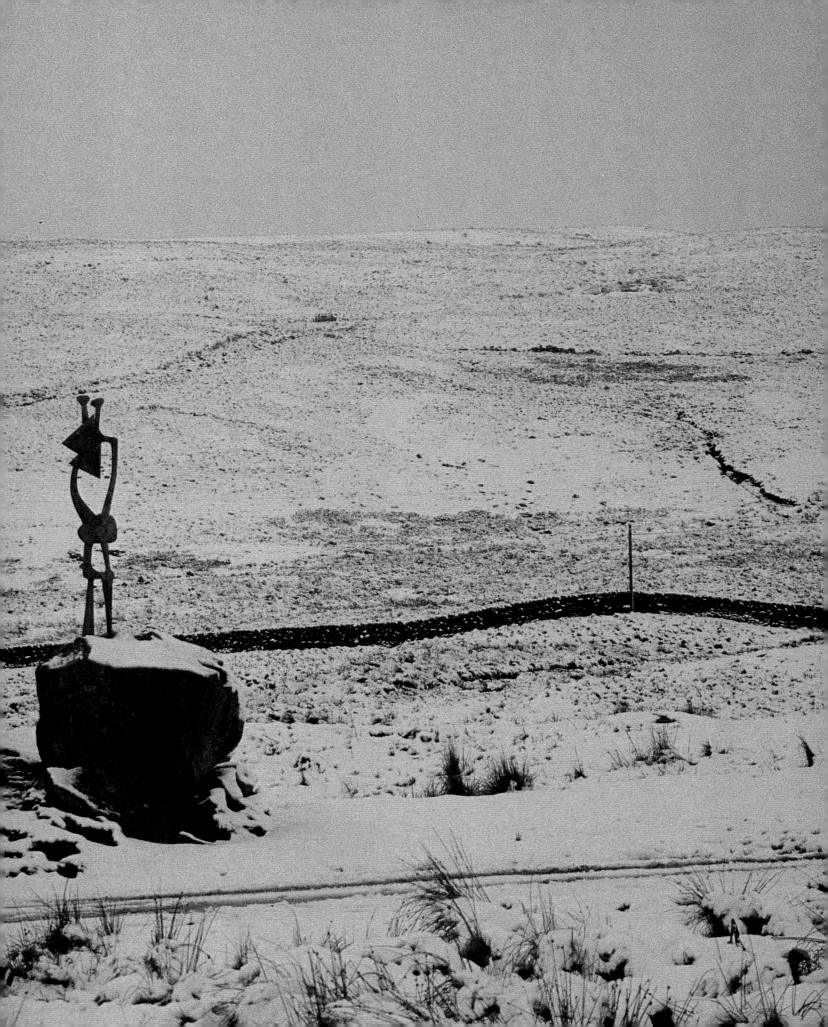

Jock Murray (forester)

Getting him in the headlamps at night makes your hair stand on end.

Henry Moore

Like a vision. Very nice indeed. It would be better without the light on the base. Just leave a little bit to show it's standing on something. The real beginning of outdoor sculpture.

The first we did. We chose a spot that needed something. Oh yes, that meant a lot to me. I spent a lot of worry over it. I went up and took photographs and had photographs with me.

Looking at John Haddington's photographs, 9 June 1985 and 25 November 1984.

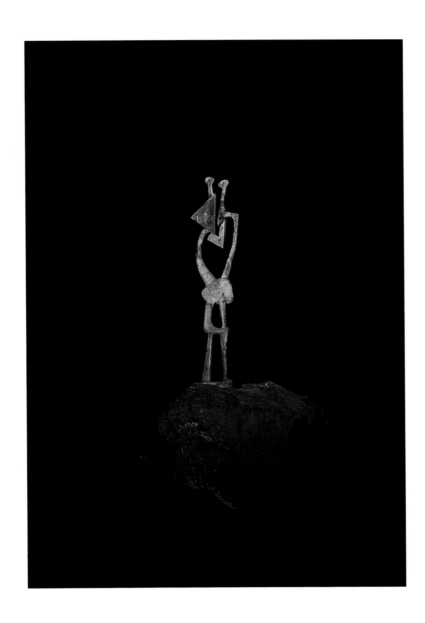

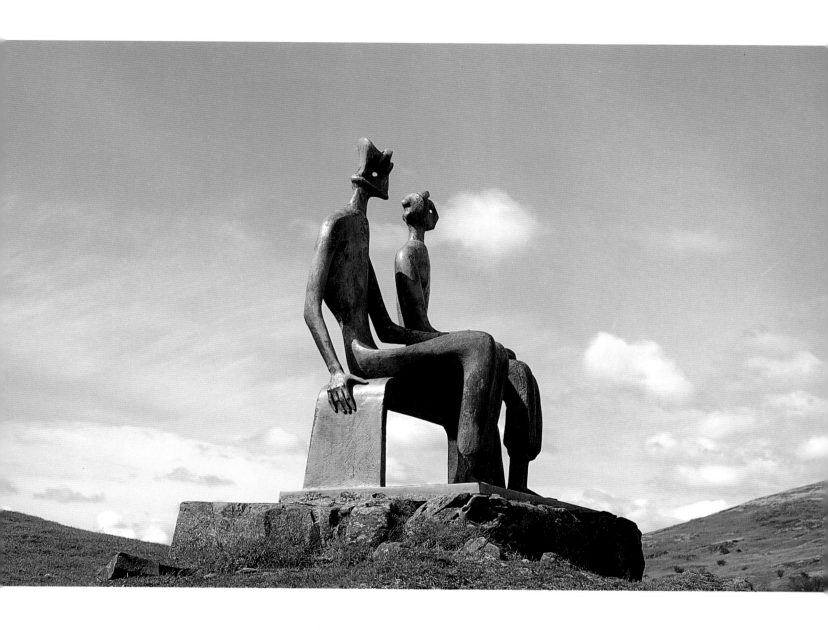

44

HENRY MOORE 1898–1986

King and Queen

1952–53
height: 5ft 4½in, 164cm
bronze, edition of 5+1

Henry Moore

The head of the King is the clue to the whole sculpture … A novelist, starting with a single incident or situation, can construct the remainder of his novel from his knowledge of life, his imagination and his art. The same thing happened with this sculpture. The head of the Queen was a problem because it had to be in harmony and I made two or three different attempts at it before being satisfied.

All this reminds me of the delegation which came from Antwerp to decide whether the city should acquire the sculpture. I had been informed from Antwerp that it was because there was opposition to its purchase that they were sending some committee members to have a look at it. They arrived in London during the terrible smog in 1953. They were due at my studio at ten a.m. but by two o'clock in the afternoon they had not arrived at Hoglands. As the fog was still impenetrable, I gave them up and went back to work on the "King and Queen". I was still unhappy with the head of the Queen and decided to saw it off, thinking that I had time to get it right. But sure enough, at 4 o'clock, still in dense fog, the delegation

arrived. They were so excited and proud of themselves at having managed to reach me that they hardly bothered to look at the sculpture. In fact, after a few minutes, they realised they had better set off back to London or they would never get home at all. When they had returned to Antwerp all they could talk about was their terrible experience. It was as if they had been to the North Pole. When asked about the sculpture, they said, "Oh! that's all right". And so the sculpture was bought.

The "King and Queen" is rather strange. Like many of my sculptures, I can't explain exactly how it evolved. Anything can start me off on a sculpture idea, and in this case it was playing with a small piece of modelling wax. It was at the time when I was thinking of starting my own bronze foundry. I had a young sculptor assistant who was keen on the technical side and wanted to know about casting bronze. I decided to cut out the first stage, which would have meant making a plaster cast, and to model directly in wax. Whilst manipulating a piece of this wax, it began to look like a horned, Pan-like, bearded head. Then it grew a crown and I recognised it immediately as the head of a king. I continued, and gave it a body. When wax hardens, it is almost as strong as metal. I used this special strength to repeat in the body the aristocratic refinement I found in the head. Then I added a second figure to it and it became a "King and Queen". I realise now that it was because I was reading stories to Mary, my six-year-old daughter, every night, and most of them were about kings and queens and princesses. Eventually one of these sculptures went to Scotland, and is beautifully placed by its owner, Tony Keswick, in a moorland landscape. I think he rather likes the idea of the "King and Queen" looking from Scotland across to England.

John Hedgecoe and Henry Moore, *Henry Moore*, Nelson, 1968, p.221.

This standing figure, like a sentinel, with an echoing double-head, is beautifully placed on a natural outcrop of rock on this Scottish moor. The siting of all my sculptures at Glenkiln, Dumfries, is marvellously varied and is, to me, ideal. It proves why I prefer Nature to any other placing as a setting for my sculptures.

Ibid., p.227.

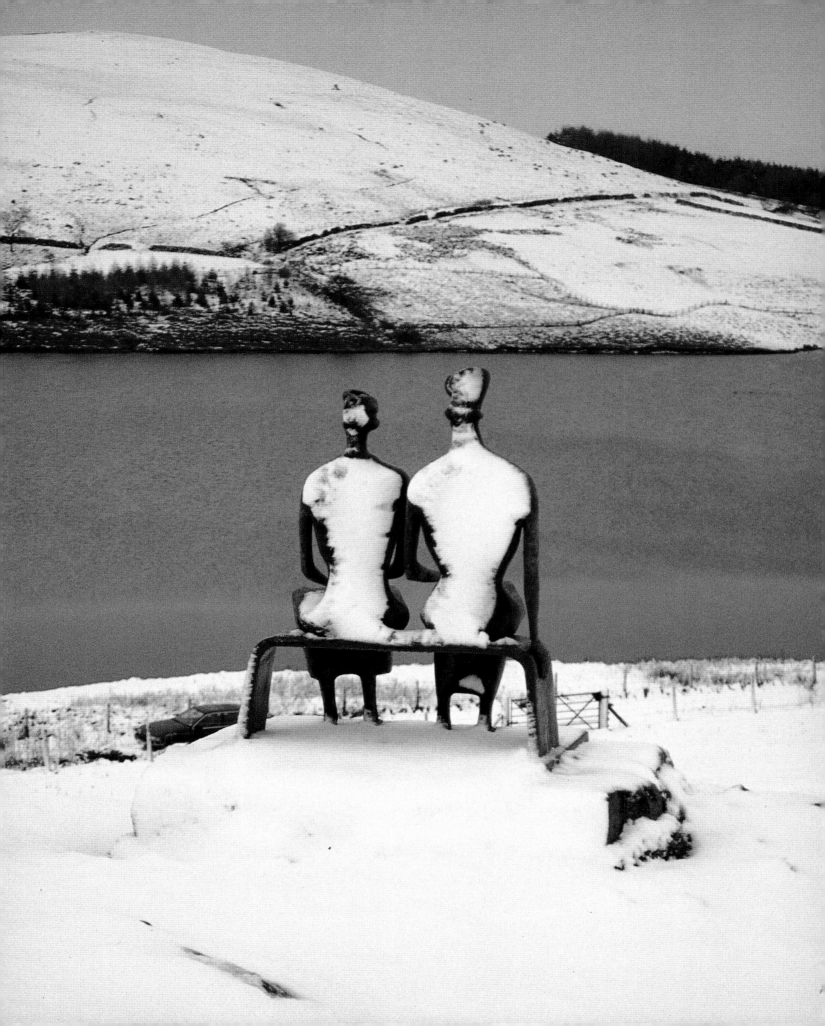

They look out on the hills and over Glenkiln Loch. The *King and Queen* have a magnificent view over the loch looking out toward England over the Border fifty miles away.

Philip James ed., *Henry Moore on Sculpture*, Macdonald, 1966, p.246.

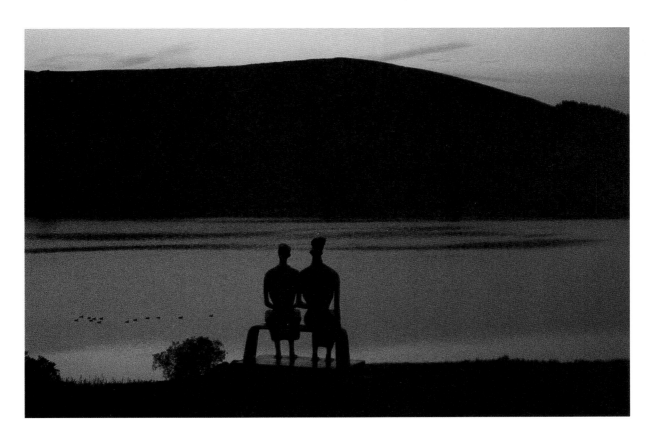

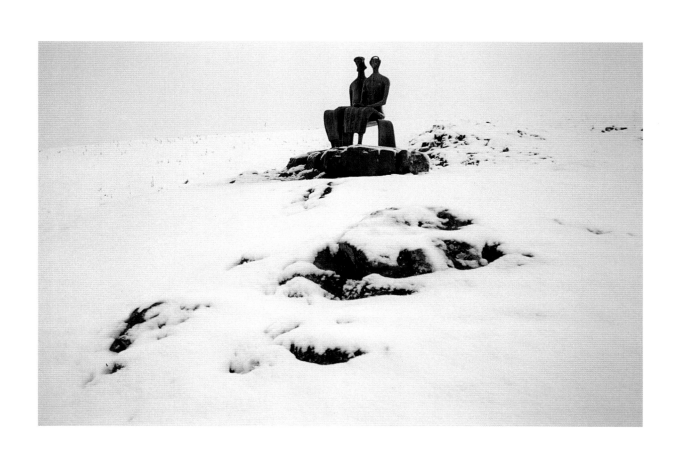

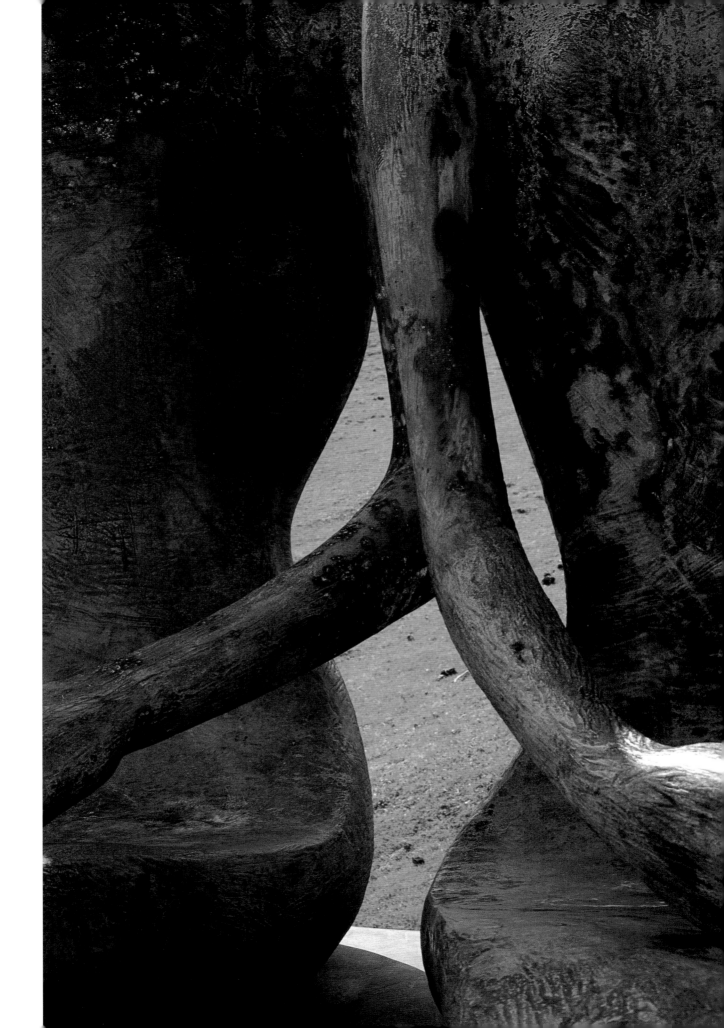

Henry Moore

This is what matters —
the light between the arms.

Sometimes a sculpture comes without any drawing. Just by playing around with clay or plasticine or whatever I use, then the idea builds itself up. Drawings can give me the mood, but you don't copy the drawing — at least I don't — because a drawing can never give you more than one side and the other sides matter just as much.

Looking at John Haddington's photographs, 9 June 1985 and 25 November 1984.

Tony Keswick

You see the place between the waist and the arm? It's a very nice shape — a sort of leaf — down to the point made by the hand. Whenever you go round you see the lovely leaf shape which he liked so much.

Tony Keswick

See the simplicity of the Queen's profile. One line for the forehead, a second for the nose, a third for the chin, a fourth for the neck – one, two, three, four, and then – Banco! – that hole for the eye in the middle that brings it all to life. [He has traced the lines in the air with his walking-stick as he speaks, ending with a conclusive jab.] The hole is absolutely crucial. By moving, you can give her a green eye or a sky eye.

The King's hands, which are perfectly modelled as you can see, are Philip Hendy's hands. He was Director of the National Gallery at that time. The Queen's hands are Moore's secretary's. The Queen has a very nice hair-do. From behind his back is convex, hers concave – that's all there is to go on and yet his could only be male and hers female. It's nice being finished-off behind – no sweeping of anything under the carpet because he doesn't know what to do. It's modelled all the way. The world thinks it's his finest piece.

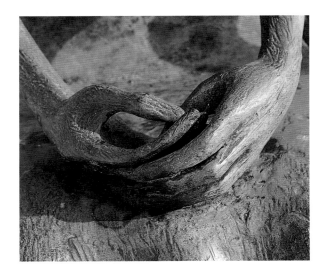

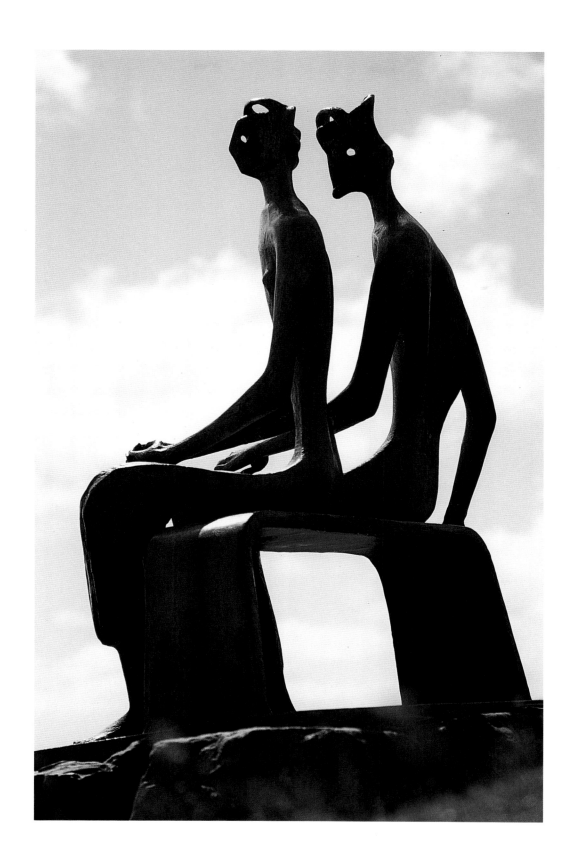

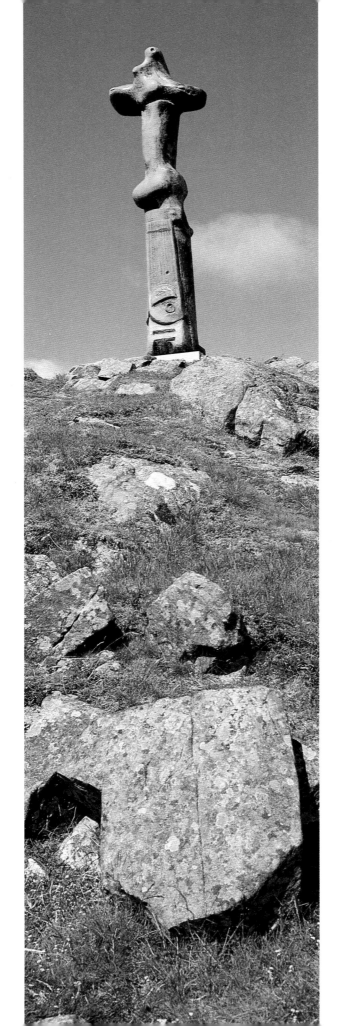

56

HENRY MOORE 1898–1986

Glenkiln Cross

1955–56
height: 11ft, 335.5cm
bronze, edition of 6

Henry Moore

I often work in threes when relating things. Take the symbolic cross motif. I realised that, wherever it was placed with others, it had to be in the middle. When placed between two others, the three became a crucifixion group. The three of them are together as a group outside the Kröller-Müller Museum in Holland, and there's another group of three in America, outside the Amon Carter Museum in Fort Worth. However, in Scotland I think the single cross is probably better placed: seen from across the moor your attention is drawn towards it as if X marks the spot. From a distance a cross form stands out so much better than any other form.

John Hedgecoe and Henry Moore, *Henry Moore*, op. cit., p.250.

Henry Moore

The maquettes for this upright motif theme were triggered off for me by being asked by the architect to do a sculpture for the courtyard of the new Olivetti building in Milan. It is a very low horizontal one-storey building. My immediate thought was that any sculpture that I should do must be in contrast to this horizontal rhythm. It needed some vertical form in front of it. At the time I also wanted to have a change from the Reclining Figure theme that I had returned to so often. So I did all these small maquettes. They were never used for the Milan building in the end because, at a later stage, when I found that the sculpture would virtually be put in a car park, I lost interest. I had no desire to have a sculpture where half of it would be obscured most of the day by cars. I do not think that cars and sculptures really go well together. One of the upright motifs, without my knowing why, turned into a cross-form and is now in Scotland ... From a distance it looks rather like one of the old Celtic crosses ...

Ibid., p.245.

I started by balancing different forms one above the other – with results rather like the Northwest American totem poles – but as I continued the attempt gained more unity also perhaps became more organic – and then one in particular took on the shape of a crucifix – a kind of worn-down body and a cross merged into one ... Because the first cast of this sculpture was placed on a hill-side at Glenkiln Farm, Shawhead, in Scotland – and because it is so beautifully placed there – it has now come to have the name 'Glenkiln Cross'.

Philip James, op. cit., p.253.

Mary Moore

The *Glenkiln Cross* was conceived, as Moore recalls in conversation with Philip James, while considering an upright sculpture as the solution for the Milan site. The *Glenkiln Cross* was originally part of a group of totem pieces which my father worked on simultaneously. The companion pieces were not conceived later. They were part of this totem group. Henry Moore explored different juxtapositions. The group of three in which the *Glenkiln Cross* is the central piece was a Crucifixion triptych with the two smaller pieces reminiscent of the thieves on either side. Also note that in the case of all these totem works, Henry Moore experimented with different techniques to give surface variety. The maquettes were conceived in plaster and clay and my father constructed them by assembling plaster casts of different parts. Surface variety and pattern were produced by, for example, casting the impression of one of his sculpture tools or the head of a nail. The scratchings on the Glenkiln Cross were really another way of getting surface variety.

Alan G. Wilkinson

By the mid-1950s Moore's working method had changed. Instead of generating ideas for sculpture in the drawings (as had been his practice from 1921 to the early 1950s), he began to work directly in three dimensions, in the form of small maquettes … The wall relief maquettes of 1955 and the series of upright motives of 1955-56 may be said to mark a turning point in Moore's development …

The 'Glenkiln Cross' is made up of three distinct units. In the top section the small orifice … is suggestive of the mouth of a primeval creature. Below this, compressed, eroded shoulders and truncated arms give the sculpture the shape of a crucifix. In the author's opinion this rugged, irregular section was almost certainly based on a flint stone. Below this is the smooth, bone-like form of the torso, the central portion, upon which the head and arms balance, not precariously, but with an organic inevitability. The swelling knob at the bottom of this section resembles waist and hips. Moore has described the third section – the rectangular front of the lower half of the sculpture – as "the column and on it are little bits of drawing which don't matter sculpturally, which represent a ladder and a few things connected with the Crucifixion" …

The Moore Collection in the Art Gallery of Ontario, Art Gallery of Ontario, Toronto, 1979, pp. 137-139.

Tony Keswick

Where the *Glenkiln Cross* is now — Henry and I were walking down below and we saw a shepherd up there — it was in the lambing time — and he was looking down at his sheep all .round. And it stood out as the most wonderful place for a bit of sculpture. If you lie on the ground near the base and look at it against the sky the profile of the top is like a face — eyebrow, nose, mouth. But from far off it looks like a cross. What the marks on the side mean I don't know, but they're very effective. In one place it looks semi-pregnant — three months gone — I'm sure that was intended.

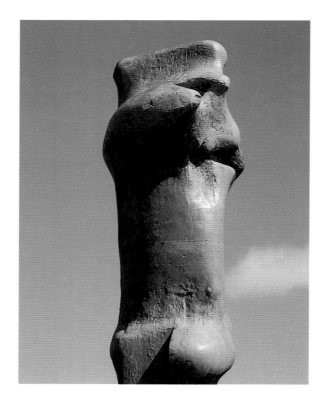

Jock Murray (forester)

Reminds me of patching the bodywork of my car — you know?

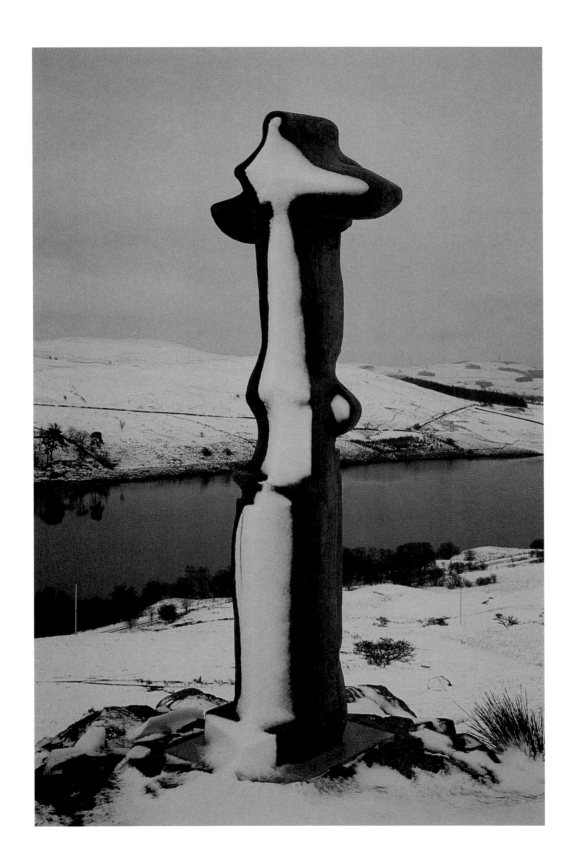

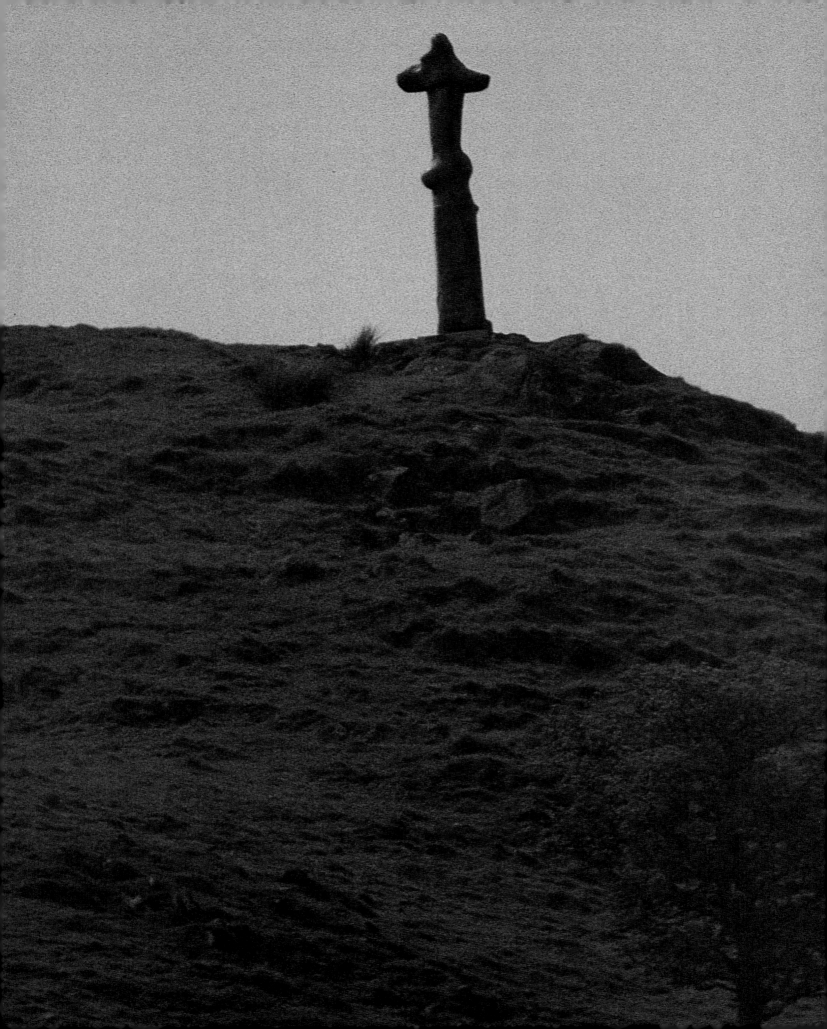

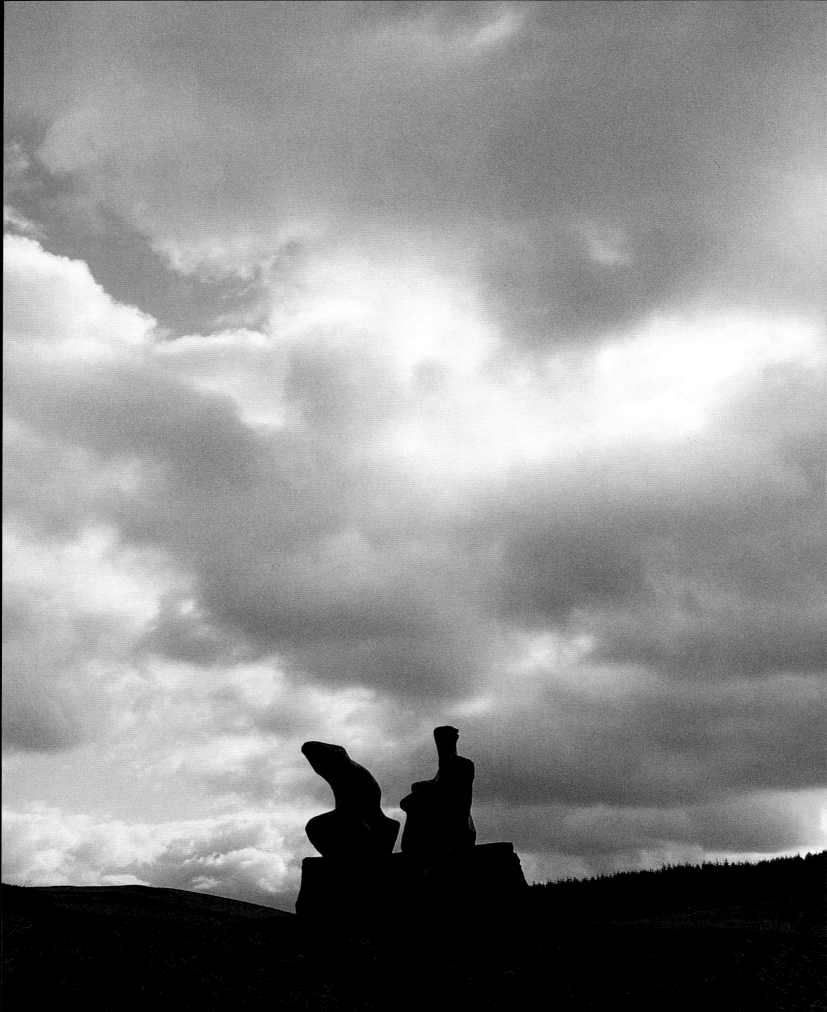

HENRY MOORE 1898–1986

Two Piece Reclining Figure No.1

1959
length: 6ft 4in, 193cm
fibreglass, unique

Henry Moore

My Two and Three Piece sculptures have the space between each part which to me is the same as spacing the knee from the foot. This space between each piece is terribly important and is as much a form as the actual solid and should be looked upon as a piece of form or a shape as much as the actual.

Henry Moore/David Mitchison, Henry Moore Foundation Archive, recording, 1980.

I realised what an advantage a separated two-piece composition could have in relating figures to landscape. Knees and breasts are mountains. Once these two parts become separated you don't expect it to be a naturalistic figure … you can guess what it's going to be like. If it is in two pieces, there's a bigger surprise, you have more unexpected views; therefore the special advantage over painting – of having the possibility of many different views – is more fully exploited.

Quoted in Philip James, op. cit., p.266.

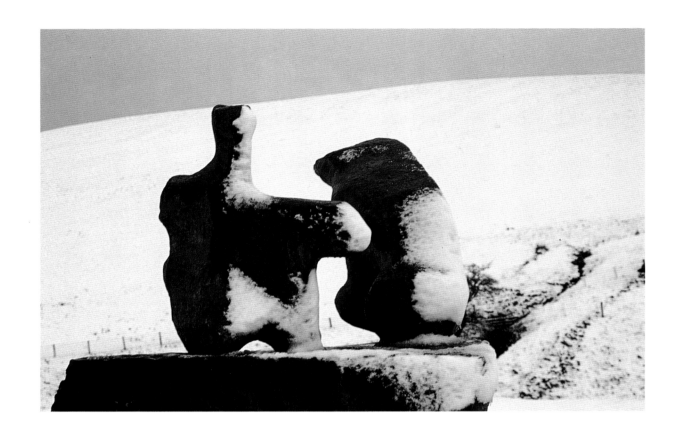

Tony Keswick

This is my least favourite. Funny, because a lot
of people like it the most; but they're all cham-
pions in their own right. Monet is Henry's
favourite painter and he used to paint seascapes
with caves – here's Monet's cave and here's the
sea [indicating the holes at the foot of the two
pieces, and the bronze base with his walking-
stick]. And from here it looks as if it's going to
take off over the hill. Weren't we lucky to get
that stone, which so suits it. I think it's very
fortunate the local stone should be so good for
the sculptures. This one weighs ten tons.

Henry Moore

This particular sculpture is a mixture of the human figure and landscape, a metaphor of the relationship of humanity with the earth, just as a poem can be.

Henry Moore: My Ideas, Inspiration and Life as an Artist, op. cit., p.113.

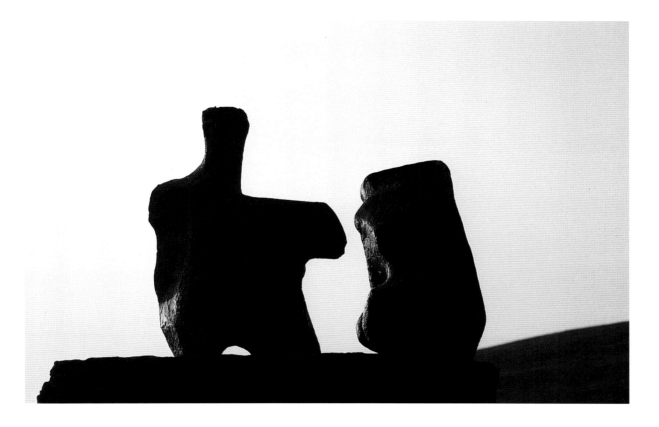

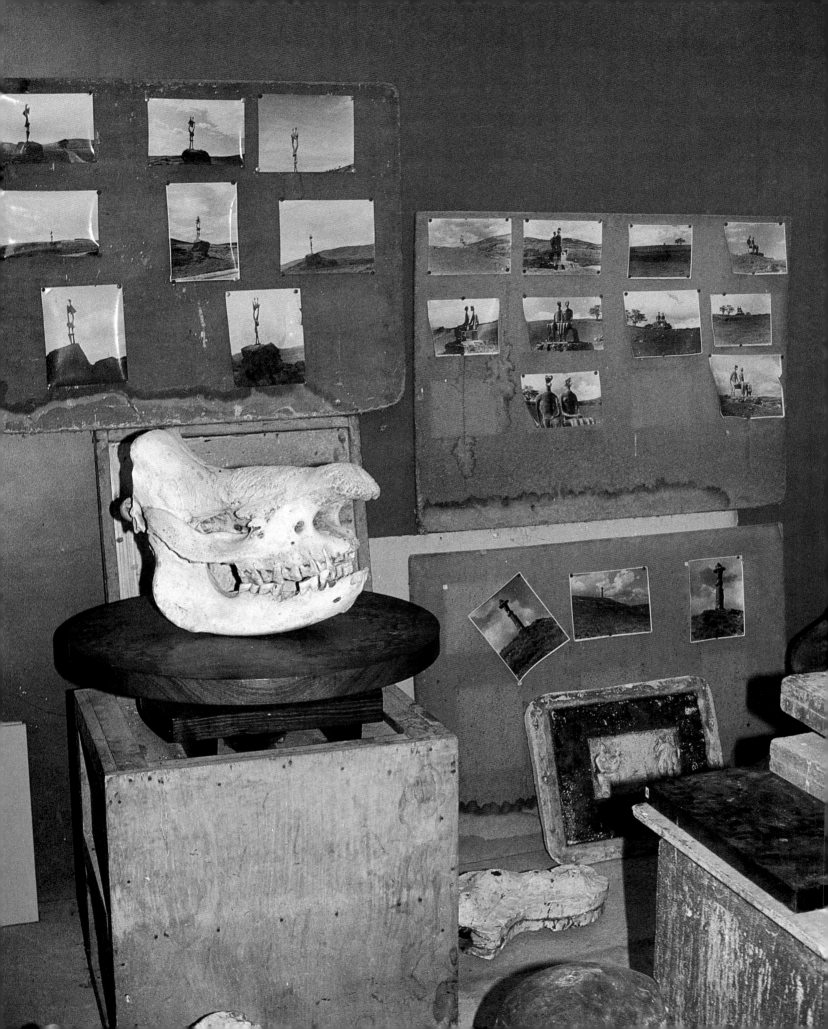

Henry Moore's working method

Henry Moore

Bronze is a wonderful material. It weathers and lasts in all climates. One only has to look at the ancient bronzes, for example, the Marcus Aurelius equestrian statue in Rome. I love to stand beneath this statue, because it is so big. Under the belly of the horse, the rain has left marks which emphasize the section where it has run down over the centuries. This statue is nearly two thousand years old, yet the bronze is in perfect condition. Bronze is really more impervious to the weather than most stone.

Quoted in Gemma Levine, *With Henry Moore: The Artist at Work*, Sidgwick and Jackson, 1978, p.148.

I like working on all my bronzes after they come back from the foundry. A new cast to begin with is just like a new-minted penny, with a kind of slight tarnished effect on it. Sometimes this is all right and suitable for a sculpture, but not always. Bronze is very sensitive to chemicals, and bronze naturally in the open air (particularly near the sea) will turn with time and the action of the atmosphere to a beautiful green. But sometimes one can't wait for nature to have its go at the bronze, and you can speed it up by treating the bronze with different acids which will produce different effects. Some will turn the bronze black, others will turn it green, others will turn it red.

Quoted in Philip James, op. cit., p.140.

... I have gradually changed from using preliminary drawings for my sculptures to working from the beginning in three dimensions. That is, I first make a maquette for any idea I have for a sculpture. The maquette is only three or four inches in size, and I can hold it in my hand, turning it over to look at it from above, underneath, and in fact from any angle. Thus, from the very beginning I am working and thinking in three dimensions.

Quoted in Gemma Levine, op. cit., p.123.

71

In 1940 Henry Moore moved to Hoglands, Perry Green, Much Hadham, Hertfordshire, his final home and today the headquarters of The Henry Moore Foundation. In the beginning his studio was a converted stable, but as the years passed he bought several smallholdings to the rear of the property. This additional land was turned into a sculpture garden and the site for further studios — conversions or temporary constructions to begin with and finally, from 1970, new buildings — the first of which is known today as the Maquette Studio.

The Maquette Studio consists of two small rooms. In the first, a picture window gives a panoramic view of farmland. There is an elephant skull, given to Moore by the zoologist Julian Huxley, and a group of plasters and moulds arranged haphazardly on tables and pedestals. Leaning against the back wall are some boards on which are pinned a number of fading black and white photographs of his Glenkiln pieces *in situ*. It seems almost certain that these photographs were taken by Moore himself. The fact that he had these permanently displayed in the room most associated with the origins of his work is proof enough of his regard for Glenkiln as the most inspirational of settings.

In the second room is a mass of small plasters and stones, bones, shells and other natural forms which Moore gathered because their shapes appealed to him. They are arranged on shelves, in drawers, cupboards and boxes on the floor, as well as scattered about a table along with some of the tools of his trade. These two rooms remain much as they were in Moore's lifetime, and offer the greatest insight into his working methods. Here is a model for the King in the *King and Queen*; it is ten inches high. This is the maquette which acts as the prototype and can be copied in scale to any size.

Moore would often incorporate found objects in his sculpture. He would take a bone or flint from his collection, press it into clay, remove it and then cast plaster in the impression, thereby turning a negative space into a positive form. These casts he might perhaps join to others; and he would play around with them and see how they worked together in the creation of a figure.

Sometimes, having selected the pieces from which he wanted impressions, Moore would get his assistants to make the casts. Then, if the form intrigued him, he might try to turn it into a figure. He would drill a small hole, fix some wire in the hole for an arm, bend it around a bit this way and that and, if he liked what was happening, build it up. This he would do by swathing the wire armature with pieces of tissue soaked in liquid plaster. He would take half a rubber ball — about the size of a tennis ball — and, using this as a bowl, mix

water and plaster and dip the tissue in it. When the plaster had hardened he could remove it simply by turning the rubber container inside out.

After he had built up the form and let it set, he would take a little file (a riffler) and file the plaster into shape, adding more plaster as required or cutting some off and starting again if he wasn't happy with it. This is called a plaster build-up. Sometimes the build-up would be just the wire armature with plaster on it; sometimes it would be based on the impression of a flint or whatever, cast in plaster and with the wire added. When the piece – still hand-sized at this point – was finished to Moore's satisfaction, he might hand it over to his assistants to be enlarged, that is, to make a scaled-up model in plaster from his original hand-held piece. Moore would then work on this plaster before it was sent to the bronze foundry for casting.

Moore was in the habit of coming to the Maquette Studio in the morning, after he had dealt with his mail and business affairs. This would usually be at about eleven. At one, he would return to his house for lunch – a bottle of Guinness, cheese, bread and an apple – and stay there for an hour or so to read *The Times* and cat-nap before returning to work until six, either in the Maquette Studio or elsewhere on pieces that had reached a later stage in their development.

This description is based on a conversation with Malcolm Woodward and Michel Muller, Henry Moore's assistants since 1968 and 1970 respectively.

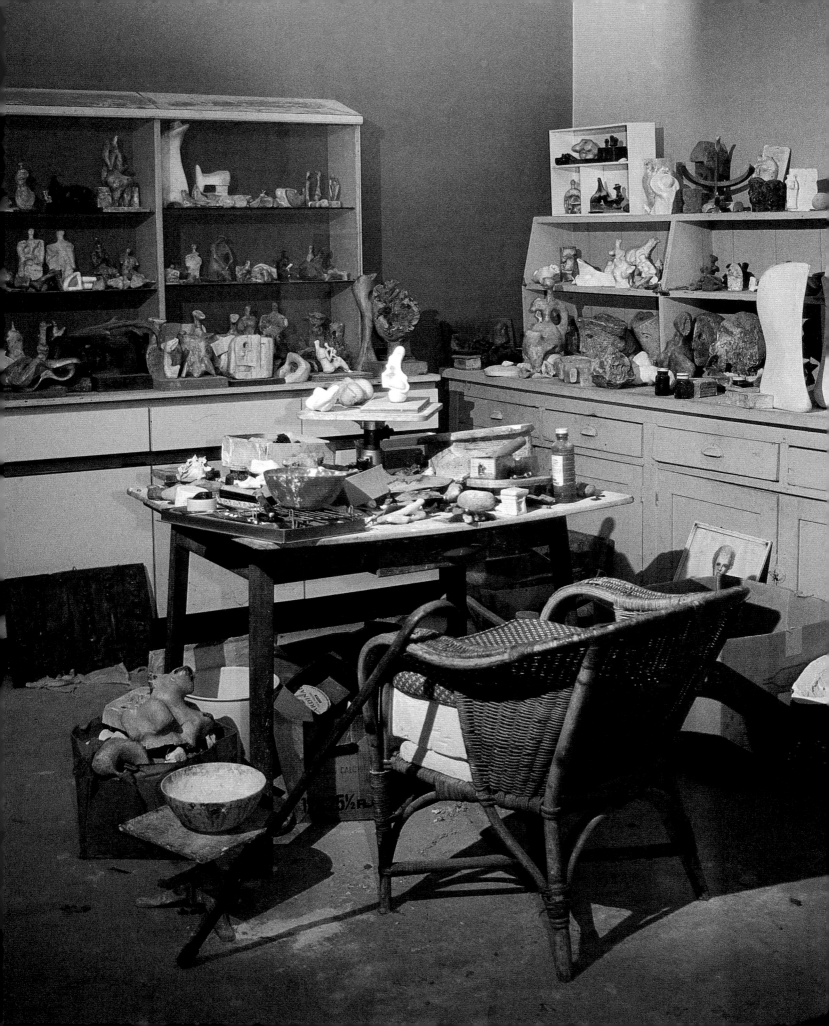

two interviews with Henry Moore

The two interviews which follow took place at Hoglands in 1984. On the first occasion, Tony introduced me to Henry Moore, the interview arising naturally out of the regular visits Tony paid Moore once old age had condemned the latter to the life of an invalid. Having criticised Moore's later work in a review for *The Spectator* of the London exhibitions celebrating his eightieth birthday – a review which might have come to his attention because Bryan Robertson had persuaded him to do a cover for that issue of the magazine – I was apprehensive; but if he did remember it, he conveyed no ill-will.

A nurse was in attendance and Mrs Moore quietly sewed. Henry Moore was confined to an armchair but well enough to be drawing when we arrived, a pile of 'reclining figures' on the floor proof that he had been busy for quite some time. He had also been keeping an eye on the television, where a snooker match was in progress. His favourite player was the unflamboyant, clinically professional, Steve Davis. We huddled on the sofa by his side.

After the formalities, the conversation turned to Glenkiln and with his permission I started the tape. After a minute or so, I glanced at the recorder to see if the reels were spinning and found to my horror they were not. Everything came abruptly to a halt before I discovered I had left it on 'stop'. Moore was extremely understanding and not in the least put out by my fluster. After twenty minutes Tony brought the conversation to a rather abrupt conclusion in his anxiety not to tire Moore. I stopped the tape and we began to make our farewells. In retrospect, I wish I had tried to involve Mrs Moore in our conversations but it seemed a rudeness at the time. As we were leaving, Moore paid much his most frank tribute to Tony, holding his hand and declaring that he 'owed it all to the boy'. 'Did you get that last bit?' asked Tony outside. I had to disappoint him.

Having broken the ice for me, Tony was anxious that I should conduct the next interview on my own, which I did. Again Henry and Irina Moore could not have been more gracious, despite the inconvenience of having a virtual stranger visiting them in their invalided state. I felt frustrated at my inability to coax more specific answers on the subject of Glenkiln, and particularly of the debt, if any, he owed Tony. What I hoped for was something along the lines of his farewell on my last visit. I stopped after twenty minutes. I had failed to get any comment on Rodin, or to unravel the meaning of the runic drawing on the side of the *Glenkiln Cross*; but afterwards I was surprised at how much more open the answers were than they had seemed at the time. As I left, he paid an even handsomer tribute to Tony and all he had achieved through the

imagination of his initiative at Glenkiln. I cursed myself for being caught out again.

I made a third visit, again with Tony, to discuss John Haddington's photographs. Most of these were slides and I had brought a viewing box. After two or three slides the light conked out in the box, so we had to squint at the slides against the daylight. Just as we were getting in our stride and the conversation was proving rather interesting, seeming to stir up new reactions on both sides, the photographer John Hedgecoe arrived unexpectedly. We left soon after in a confusion of farewells, my carefully prepared ploy of leaving the tape running now to no avail. John Haddington never did manage to get a photograph of Moore and Keswick together, so none exists. John Hedgecoe probably had a camera with him — what a pity I did not ask him. And yet, would they have wanted their friendship commemorated by a photograph taken when they were so far past their prime? I do not think so.

Henry Moore in discussion with Tony Keswick, 4 May 1984

Henry Moore I think for some time I had been concerned with how my sculpture was seen or shown. I mean, an exhibition in the Leicester Gallery was all right but it didn't get to the general public. You'll have to tell your part now, Tony, of why you should've come to me and said "I have an estate up in Scotland" – this and the other – you described it a little bit, you said, "I think a sculpture by you would look quite well there … "

Tony Keswick Well, there was a big, enormous rock. And just like a table can be much nicer with an ornament on it, I thought your *Standing Figure* would be nice there.

Moore Now but where had you seen the *Standing Figure*?

Keswick I saw it in your studio here. I came here and fell in love with the *Standing Figure*. And you were kind to me, you didn't kick me out, and eventually I got it and I put it on the rock. And then you came up and you approved it, I think.

Moore Oh I came up and I was staggered, at the …

Keswick At the surroundings …

Moore At the natural beauty, and here was a chance to inhabit it a bit. For me it was a very exciting project from the start.

Keswick And the *King and Queen* came next.

Moore Then the *King and Queen*. Well, then one began to realise, I mean I had in mind the *King and Queen*. It's wonderful up there, because you're with nature. People don't matter. It's the rocks and the sky and the distance and so on. Oh yes, it really gave me a chance to begin to relate my sculpture to nature, which was just right at that time.

Keswick Do you remember what old "K" said, Henry? "You shouldn't let Tony have any more of your good things because he puts them out on rocks in the country and that's silly." But old "K" came round.

Moore Yes, of course he did.

Keswick But he liked them very much in the end. He saw the point.

Moore Yes, he did. But "K" had been Director of the National Gallery – he was used to works of art in a very close relationship to people and himself and so on. No, it was a tremendous experience for me to see the sculpture with absolutely real nature.

John McEwen Did this remind you of your childhood, do you think, rocks on the moors in Yorkshire and so on?

Moore Not consciously, no. No, I was just staggered by seeing it against real nature.

Keswick Simple and beautiful.

Moore Yes. You could imagine no other human being existed but yourself.

McEwen And do you think it had a decisive influence on your thinking and your work at that point?

Moore Oh yes, oh yes. It gave reality to this idea of sculpture with nature, and it made a real example.

McEwen So it shifted the way you worked, having seen it at Glenkiln?

Moore Oh yes, one began to think of other natural things, where they might go – on water, for instance – it began to make sculpture part of reality and not just exhibitions, in art galleries.

Keswick And you could place it when you wanted with your eye – against the sky, without being cut by other things and interrupted.

Moore And also it changes from where you look, and the day you see it and everything else, whereas in a gallery all those conditions of life and nature are missing.

McEwen Would it be fair to say that of all the places your work is shown, Glenkiln is your favourite?

Moore It is. I think that the vastness of the sky and the distance is a wonderful contrast to the man-made object. If the situation gives you an insight into the thing you're looking at, and it doesn't interfere and it adds to something, that's what you want. What you don't want is a relation-ship that's distracting. I mean, having motor bikes run past every second or I don't know what. You want peace and quiet to contemplate. Glenkiln was an experiment which came off. It gave me an experience I'd not been able to have before. I mean, here I could put things out in real nature.

McEwen Did you have Glenkiln in mind when you conceived the *Glenkiln Cross* – because it seems so perfectly to fit the setting …

Moore Yes, but you can't do that. You can't go to somewhere and then say you'll do such and such a thing that you've never done before – it can't come into your mind just like that …

Keswick It was a good site.

Moore It was a jolly good site. One knew that whatever went there that was simple and real and had a character of its own would come off all right: because there's nothing to distract you from the object and the light and the surrounding nature.

McEwen How did the *Glenkiln Cross* come about?

Keswick We saw the site. We were walking back to the house, and I think I said to Henry: "That would be a wonderful place; some day we must get something there." "Yon Figure" was standing, I think, just outside the door and I thought it was very nice and Henry came back from his Harvard professorship and he allowed me to buy it. The bad and silly thing was I didn't tell the keeper.

Moore What do you mean?

Keswick I didn't tell the gamekeeper in Scotland that it was coming. And it came in a packing case. And he said, "What the hell is this?"

Moore I didn't know that, yes. [*laughter*]

Keswick "It must be a spare part for the tractor!" So he sent it to the farm. And I had to retrieve it.

Moore [*laughter*] But why should one expect the average person who's never experienced sculpture, why should one expect them immediately to welcome an idea like that?

Keswick Of course.

Moore But the *Glenkiln Cross*: once you'd decided, you took it back ...

Keswick And Henry very kindly said it could be called the *Glenkiln Cross*.

Moore Could give it the name. I'm glad it was given.

Keswick But it's part of another piece in Amsterdam or somewhere, isn't it?

Moore Yes, I forget what ... But you have to give a name to something. You can't keep saying: "You know that piece that's very tall", and this, that and the other. If you give a name to something and people connect the name with it, you just mention the name and the piece comes into their mind.

Keswick And anyway, it's given a great deal of joy to me and many, many others.

Moore Well, it's been a great experience for me, too. No, no – it made me realise that for certain sculptures nature is the best complement.

McEwen Yes, in one of your interviews you say that you like 'wonderment' to be one of the effects of art, and I think that is certainly encouraged by a natural setting, don't you?

Moore Well, of course art should give you something ordinary living doesn't. I think the first time I went into the Sistine Chapel – my goodness – you cannot have that kind of experience by eating your first sandwich or whatever!

McEwen On the trunk of the *Cross* you've drawn a ladder, a sun and a moon – why did you do that?

Moore I've forgotten. You don't remember every thing you do! No. Glenkiln made a big point in my sculptural development, being able to relate sculpture to real life, to nature.

McEwen And have you seen it in all weathers?

Moore I've seen it quite a few times. Not like Tony does, of course – but that's only like seeing people ...

Keswick On wet days or fine days ...

Moore Or in different moods.

McEwen So the weather is immaterial.

Moore No, sometimes not. No, but it may be just the thing, like seeing a person in a situation you have not seen them in before: you learn a bit about them. And seeing a sculpture in a different situation you learn a bit about it that perhaps you didn't notice.

Henry Moore: extracts from a conversation with John McEwen, 17 May 1984

Since Glenkiln I've got to know Tony so much better, but I liked him before then – but we hadn't made the contact that we have since, over and over. I remember he came here, and he'd heard or knew that I liked seeing my sculpture with nature – I think I'd written it somewhere – and he said he had [the Glenkiln] estate. It put a picture in your mind of a lovely landscape, and he said he thought he had the perfect site. We made an arrangement for me to go, and of course when I saw it I was staggered by the space and peace and quiet and pure nature. So I began to think then what would be right in it.

You can't put out-of-doors too small a sculpture, because the outdoors makes a sculpture look smaller. The ordinary life-size sculpture put out-of-doors, if it was of a person [would make you] say: "What a small man that was that he did it from!" Because the sky, the clouds, the distance and so on all diminish the impact. A sculpture in a room like this, it can be as small as you like but you can get a full contact with it.

And so I went up, Tony met me, we drove out, and I was entranced with the site and the idea. And I knew then that it would have to be something that would mean something from a distance, and I began to think. Because that landscape is so immense, and you often approach sculpture out-of-doors from a distance, if, from a distance, you don't get any impact – it doesn't impress you and you have to wait till you get up close to it – then it's only like seeing it indoors. Anyhow, I went up there and I was delighted and staggered by the landscape, because it was pure – at least it was then, because there were no sculptures there. Space and nature: man faced with nature. So I said, "I'll think about it but it needs a very special piece." And I made the *Standing Figure* I was working on a bit bigger than I would have done, which is a bit over life-size, eleven or twelve feet. And that really began the absolute experience of trying to put my sculpture with nature. Since then we've done other things up there, and in other places, but that was the first one in which I really tried to relate a piece of my sculpture to pure nature – not to anything to do with man and man's buildings and man's work, but nature – space, distance and landscape. And never so successfully as at Glenkiln. There's no other site I've found as perfect as that or come anywhere near it. Nothing has overshadowed it in my mind.

[Glenkiln] was an extraordinary initiative of Tony's. I was surprised, yes, I don't know what made him think of it; but he must have thought of my sculpture in that relationship because it would have been no good to have got – well, even Rodin didn't do outdoor sculpture quite, in my opinion, big enough. He made the attempt in London with *The*

Burghers of Calais but they would do better for being a bit bigger. Anyhow, I'm very grateful to Tony for starting me with that real connection, real experience of working with nature. Also I began to be asked by other clients – architects (in most cases) who'd seen photographs of [Glenkiln] and sometimes of course the actual site, and been most impressed – I began to be asked for sculptures for buildings and out-of-doors.

Tony and I chose the site for *Standing Figure* between us. I got Tony to stand – oh, he's pretty big! – I got him to stand around before we hit on the exact spot, because it's the sky and distance you have to think about, as I've said. Indoors you've got a ceiling and walls … And I'm delighted with the results. The *Standing Figure* was the great breakthrough for me, the most thrilling experience. After that, with the later Glenkiln pieces, it was inevitably less of an experiment. We began to try to find others that would fit in with Glenkiln, but by then it had led to so many different open-air exhibitions and settings, that it's more difficult to recall.

Before that, I don't think sculpture had been shown in the open air, except in the form of individual monuments, war memorials, that kind of thing, not sculpture for its own sake, in its own setting. Without Tony, this would never have happened: of all the collectors who have wanted my work, he is the only one who opened up a whole new outlook and direction for me. He knows very well where he wants the sculpture placed – well, I mean he thought of it to begin with! It wasn't me going up there and telling him I thought this moor would make a good place for showing off my sculpture! And he was right. I think by then I might have had some of my pieces out here in the grounds; but Glenkiln is real nature, not civilised, man-made, sites. Tony had an outlook about sculpture and nature that no one else had had. I don't know if, so you say, he is an eighteenth-century man; I can't think of anyone making this kind of experiment in the eighteenth century, but people did want to make their mark on nature then, it's true.

I don't have a paternal affection for him – he has one for me, I think! No, it's a mutual liking, a mutual contact, response to each other, to each other's point-of-view. There are some people that as soon as you meet them, you like them. You've got something in common, humanly. He influenced me a lot in that he had this idea of showing my sculpture with nature, but he didn't influence me in making specific things, in giving the idea of a sculpture. I had to think of that. It wasn't he who gave me the idea for a *Standing Figure* – I guessed that. I think the rock on which the sculpture stands was there already. You couldn't move it.

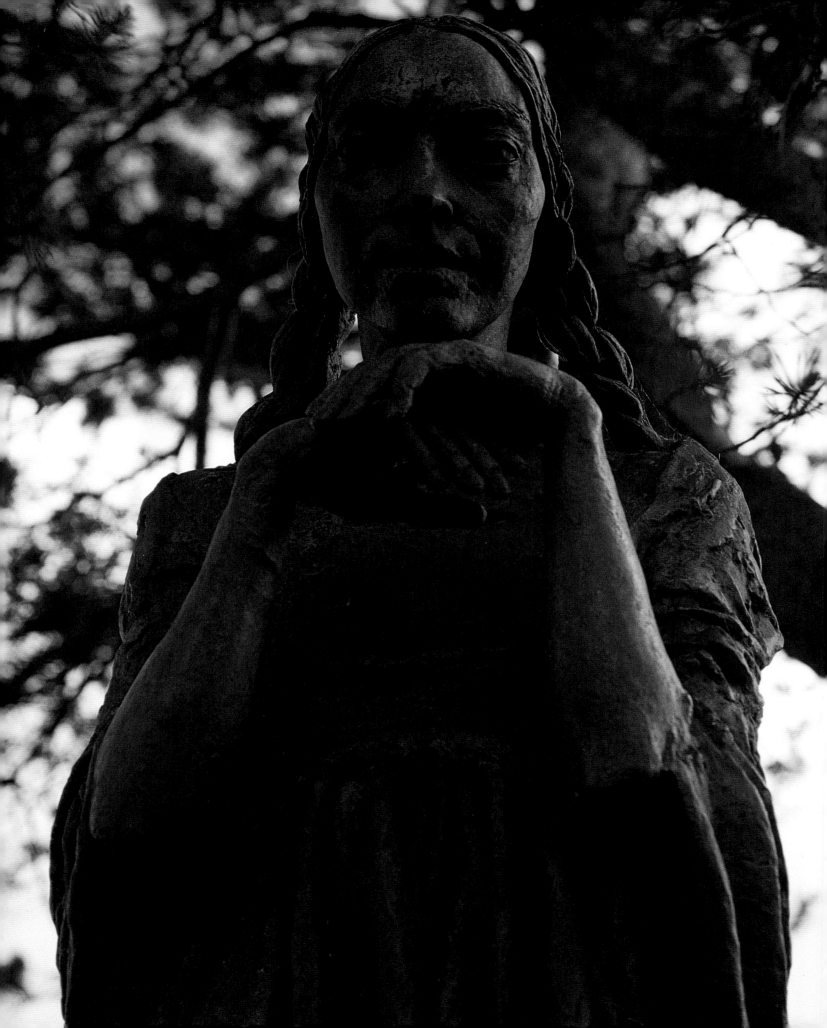

JACOB EPSTEIN 1880–1959

Visitation

1926
height: 6ft 6in/165cm
bronze, edition of 8

And Mary arose in those days, and went into
the hill country with haste, into a city of Juda;
And entered into the house of Zacharias, and
saluted Elisabeth. And it came to pass, that,
when Elisabeth heard the salutation of Mary,
the baby leaped in her womb; and Elisabeth
was filled with the Holy Ghost: And she spake
out with a loud voice, and said, Blessed art thou
among women, and blessed is the fruit of thy
womb. And whence is this to me, that the
mother of my Lord should come to me? For, lo,
as soon as the voice of thy salutation sounded
in mine ears, the babe leaped in my womb for
joy. And blessed is she that believed; for there
shall be a performance of those things which
were told her from the Lord

Luke i, 39-45

Epstein depicts the Virgin Mary in the mo-
ment that she is recognised as the mother of
God by her cousin Elisabeth, the first mortal
empowered with this knowledge. The child
that leaps in Elisabeth's womb is John the Bap-
tist, whose conception, like that of Jesus, was
announced by the angel Gabriel. So there is a
subjective connection between this piece and
the Rodin, as well as the formal connection,
Rodin being the prime influence on Epstein.

Jacob Epstein

In 1926 in Epping Forest I modelled a life size figure which I intended for a group, to be called 'Visitation'. I can recall with pleasure how this figure looked in my little hut which I used as a studio. I should have liked it to stand amongst trees on a knoll overlooking Monk Wood. This figure stands with folded hands, and expresses a humility so profound as to shame the beholder who comes to my sculpture expecting rhetoric or splendour or gesture. This work alone refutes all the charges of blatancy and self-advertisement levelled at me.

Epstein: an autobiography, 2nd ed., with an introduction by Richard Buckle, Vista Books, 1963, p.112.

Henry Moore

He was a modeller, rather than a carver. To put in other terms, his was a visual rather than a mental art, and with him the emphasis was on subject rather than on form. He was an intensely warm man, who in his work transmitted that warmth, that vitality, that feeling for human beings, immediately. His master was Donatello, rather than Michelangelo; and in Rembrandt, whom he also studied most carefully, it was the direct and personal warmth that affected him perhaps more than the formal side.

'Jacob Epstein: An Appreciation', *The Sunday Times*, 23 August 1959.

Tony Keswick

Same old technique as on the hill – you can alter your view according to the slope. Amusing. And aesthetically it's nice as a site – the trees are Scotch pines, which are very much of this country, and the patina of the trunks is more or less the same as hers. An interesting thing is the parallel of the trunks – they're very complementary those lines going up, don't you think? She was out in the open to begin with and it didn't work at all. As you know she's eight months gone or something, with a baby, and she looked neglected. Now the sheep come in here for shelter on wild days or if there's snow; it's peaceful, not dolled up.

'K' Clark was talking about the modelling, which is very rough here at the back, and he said: "If you had a hammer and knocked a corner off she would still be inside." True. She's got a very nice hair-do. The model was his Lebanese mistress. Sad face. The trees guard her.

I think you could criticise one thing, but I did it on purpose – you're supposed never to put things skew-whiff, at an angle. The little wall all the way round is rectangular and her base is not going with the rectangle, it's slightly across. I did it because I thought it was a good idea for her to look down on Glenkiln. I had the platform two feet higher at first. Then I took it down. You don't want to draw attention to a platform. I like this old Eppers and Rodin. I think they're just enough outsiders to make it that much more interesting. They don't dominate but they're in pitching. And 'K' thought this the best Epstein there is. So they enhance old Henry.

Mary Keswick

For a long time people never knew about her. She's a dear girl. I always think she looks after us.

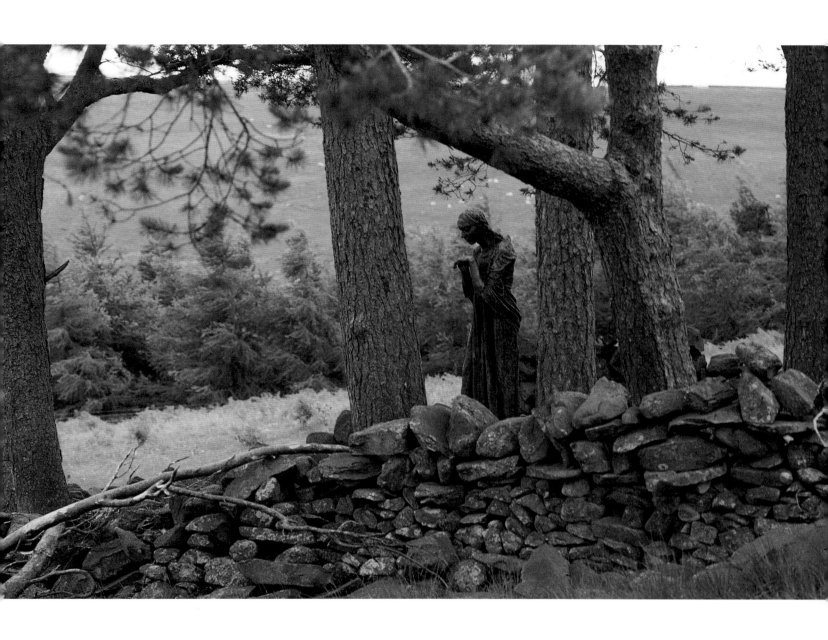

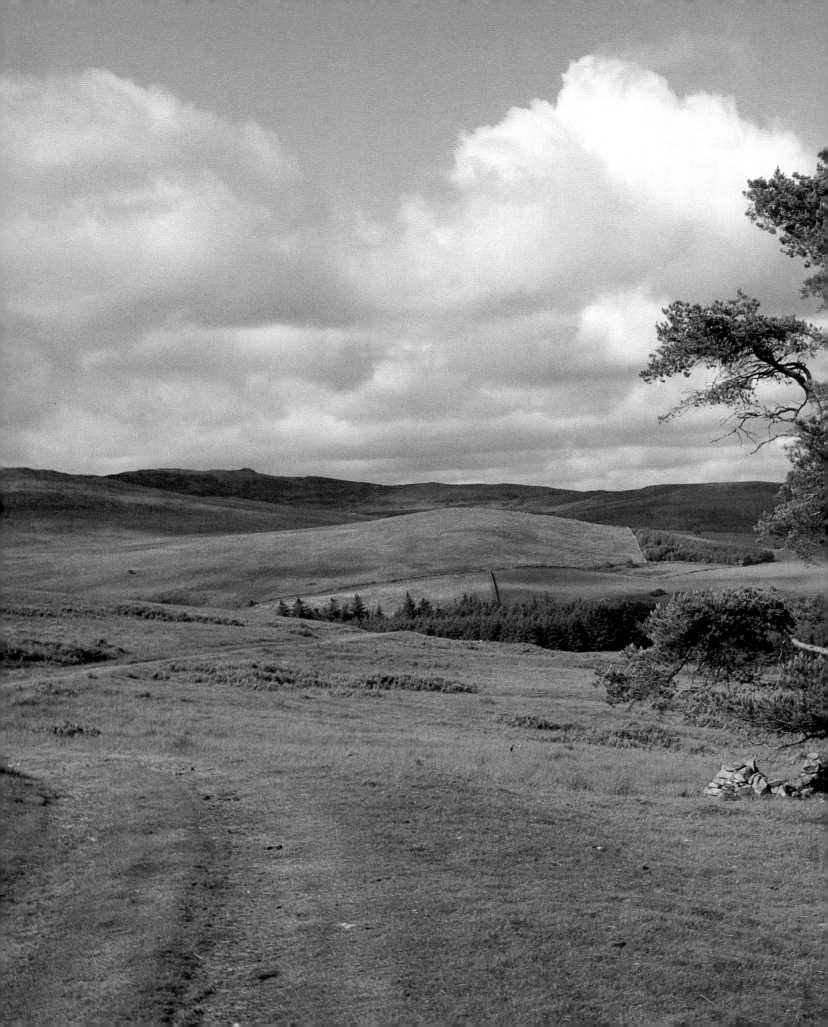

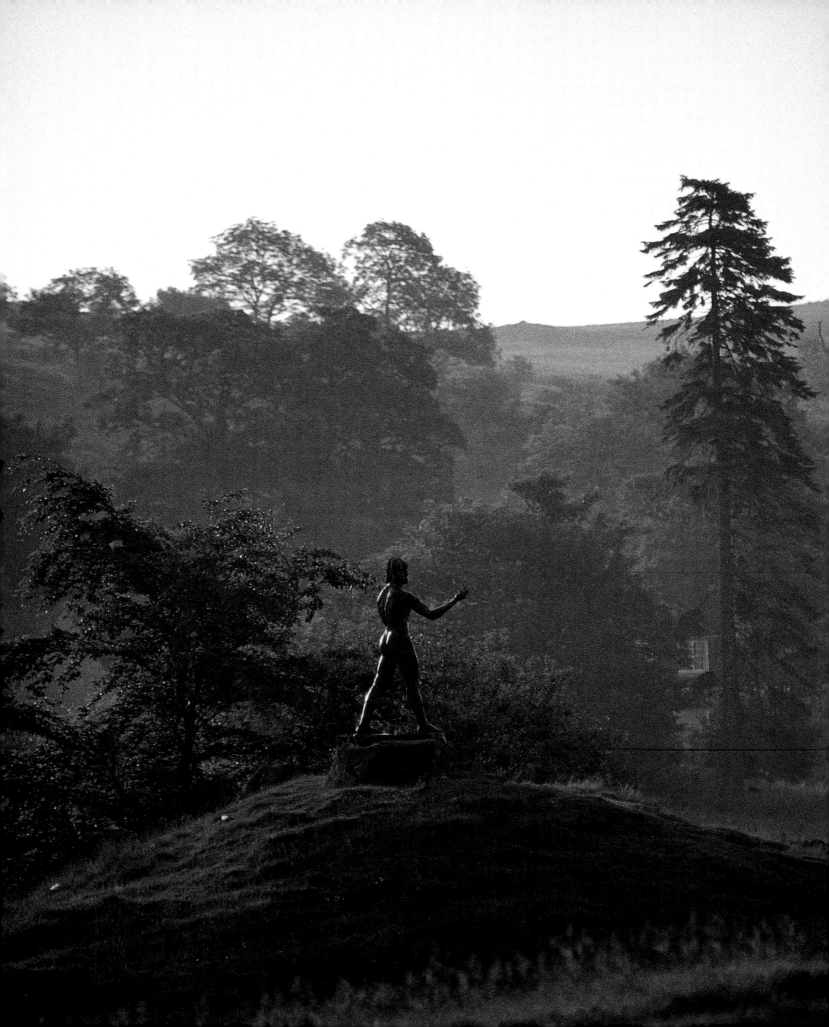

John the Baptist

1878–80
height: 6ft 6in/ 200cm
bronze, edition unlisted

John the Baptist was the forerunner and herald of Jesus Christ, of whom Christ himself said: "Among those that are born of women there is not a greater prophet" (Luke vii, 28). John's parents were a priest of Jerusalem, Zechariah, and Elisabeth, a kinswoman of the Virgin Mary. Elisabeth was barren and old, and the miraculous birth of her son was foretold by the angel Gabriel, who also proclaimed the child's future: "And many of the children of Israel shall he turn to the Lord their God. And she shall go before him in the spirit and power of Elias, to turn the hearts of the fathers to the children, and the disobedient to the wisdom of the just; to make ready a people prepared for the Lord" (Luke i, 16-17). About AD 27, John reappears as a wandering preacher: 'For this is he that was spoken of by the prophet Esaias, saying, "The voice of one crying in the wilderness, Prepare ye the way of the Lord, make his paths straight"' (Matthew iii, 3). He called for sinners to repent, and those who confessed their sins he blessed and forgave by baptising them in the river Jordan. He gained many followers, including several who were to be among the twelve apostles of Christ.

Some thought John himself must be the Christ, but he was quick to dissuade them of the idea: "I indeed baptize you with water; but one mightier than I cometh, the latchet of whose shoes I am not worthy to unloose: he shall baptize you with the Holy Ghost and with fire" (Matthew iii, 16). When Jesus came to be baptised by John, the Holy Spirit descended on him in the form of a dove and God the Father spoke from out of heaven: "This is my beloved Son, in whom I am well pleased" (Matthew iii, 17).

Soon after, John was thrown into prison; he had rebuked Herod Antipas, the Roman governor, for living with Herodias, his half-brother's wife. During the celebrations of Herod's birthday, Herodias's daughter Salome danced so beguilingly that Herod promised her anything she wished. Prompted by her mother, she asked for the head of the imprisoned Baptist, which was duly brought to her on a dish.

Pignatelli, Rodin's Italian model, gave him the idea for 'St John the Baptist'. He took up a pose spontaneously on the stand, and Rodin asked him to keep it. Originally the figure carried a cross on his shoulder, but, like the lance in 'The Age of Bronze', this was removed. Another model, Danielli, posed for the facial expression. The head of the Baptist was shown in bronzed plaster at the 1879 Salon, the whole figure a year later, when Rodin received a third-class medal. The bronze at the 1881 Salon was purchased by the French State.

Rodin: Sculpture and Drawings, Arts Council of Great Britain, 1970, p.27.)

Auguste Rodin

The science of modelling was taught me by one Constant, who worked in the atelier where I made my début as a sculptor. One day watching me model a capital ornamented with foliage – 'Rodin,' he said to me, 'you are going about that in the wrong way. All your leaves are seen flat. That is why they do not look real. Make some with the tips pointed at you, so that, in seeing them, one has the sensation of depth. Always remember what I am about to tell you,' went on Constant, 'Henceforth, when you carve, never see the form in length, but always in thickness. Never consider a surface except as the extremity of a volume, as the point, more or less large, which it directs towards you. In that way you will acquire the science of modelling.'

Auguste Rodin, On Art and Artists, translated by Paul Gsell and Mrs Romilly Fedden, with an introduction by Alfred Werner, Peter Owen Ltd, 1958, pp. 76-77.

Rainer Maria Rilke*

And we have that 'John' with the eloquent, agitated arms, with the great stride of one who feels another coming after him. This man's body is not untested; the fires of the desert have scorched him, hunger has racked him, thirst of every kind has tried him. He has come through all and is hardened. The lean, ascetic body is like a wooden handle in which is set the wide fork of his stride. He advances. His arms express it, his fingers are widespread, seeming to make the sign of striding forward in the air. This 'John' is the first pedestrian figure in Rodin's work. Many follow.

Rodin and Other Prose Pieces, translated by C. Craig Houston, Quartet Books Ltd, 1986, pp. 16-17.

Henry Moore

I certainly knew about Rodin. I remember my father showing me some photographs of his sculpture, and this may have been as early as 1904. And when I was demobilised in 1919 and went to the Leeds School of Art, I remember making a figure influenced by Rodin, a figure of an old man with a beard.

Arts Council, 1970, from an interview with Alan Bowness

I think we were all influenced by Rodin, even Brancusi.

Ibid., p.9.

This is in my opinion the greatness of Rodin, that he could identify with and feel so strongly about the human body. He believed it was the basis of all sculpture. He understood the human figure so well and loved it so much that this is the universal quality in him. And out of the body he could make these marvellous sculptural rhythms. It's interesting that he talks about sculpture being the art of the hole and the bump – all his sayings on sculpture are about physical reactions to it.

Ibid., p.10.

It's got a good side light – not back, not front – but side.

Looking at John Haddington's photographs, 5 June 1985.

* The young poet and the much older artist became friends through Rilke's writings about Rodin's sculpture, to the extent that Rodin offered to help Rilke financially by employing him as a secretary.

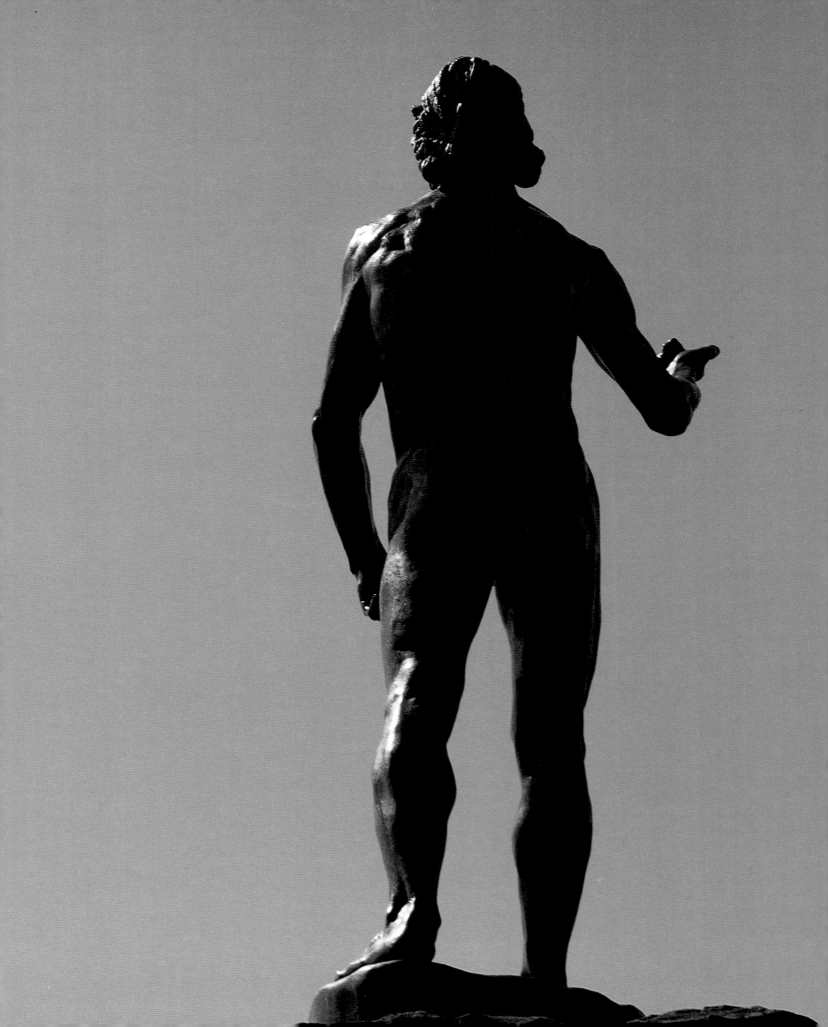

Tony Keswick

Rodin liked a plane that light would bounce off. Do you see the arm? Light is bouncing off that now, because he knew how to give the muscle a little bit more kick. And in contrast he's done the face matt – so that not a bit of light is coming off it; a little bit off the nose, but the cheeks he's got absolutely matt. I'm pontificating – but this is one of the best examples you can get of Rodin with that thing of the light coming off; the best bouncing light of any sculpture I know. Henry is very keen about it too – you can see it in the *King and Queen*. If I did that arm the light would only come off in one direction, but Rodin's comes off in every direction. Look at the light coming off the chest by use of those planes. He does it by modelling – and by knowing the muscles exactly. Another thing about seeing it outside is you can go round it and see it from all levels – against sky, water or hill. Next time you see it in a museum I think you'll agree it looks imprisoned – with people rushing round it and cutting it off. Distance is so important. He's in command. "I wish old Rodin could see it", that's what Mr Moore said.

Mary Keswick

He looks wonderful in snow or in a gale of wind or the wet or any weather really.

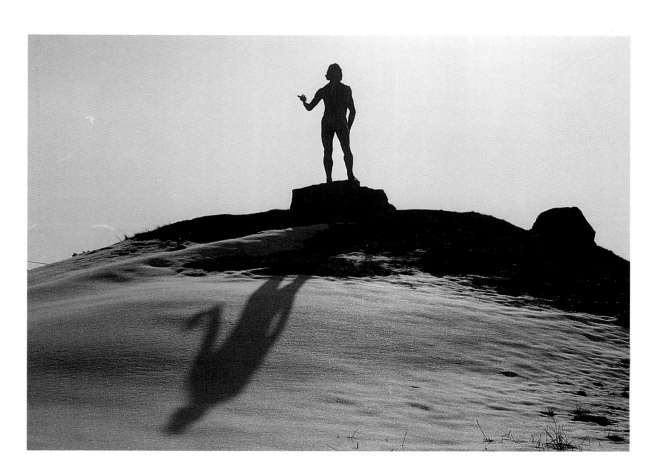

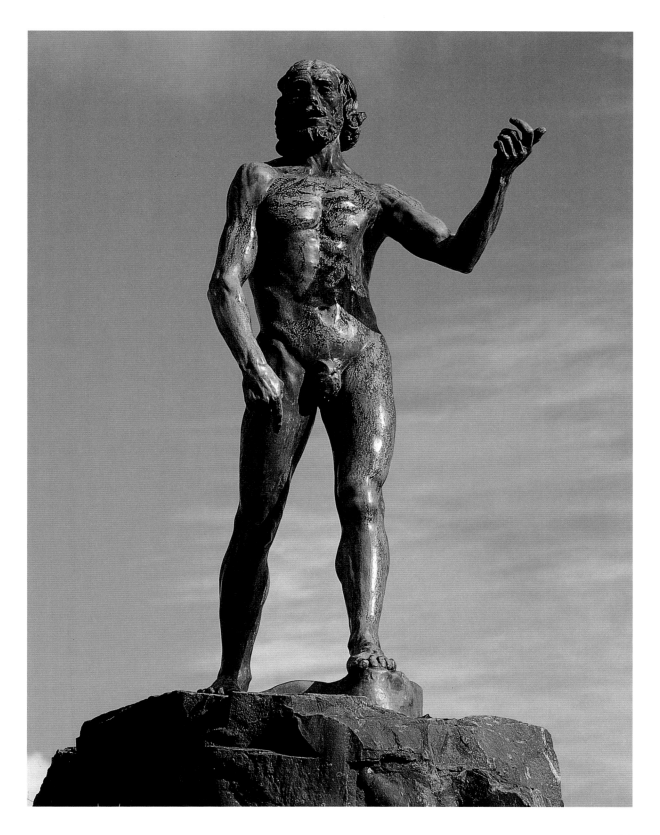

three memorials

Peter Fleming memorial

A stone gate-post inscribed with a phonetic translation of the author's surname in Chinese and the words: 'RPF for many years behind this dyke he smoked his pipe and waited for pigeons. August 1971.'

(Robert) Peter Fleming (1907–1971) was a writer, soldier and gentleman farmer. As an author, he made his reputation with books of style and humour chronicling intrepid journeys in the far East and South America. Later, as a historian, he consolidated this literary reputation. He served with notable courage in World War II, receiving (among other decorations) The Order of the Cloud and Banner (Chinese) for his work in South East Asian Command (SEAC). He was the elder brother of the novelist Ian Fleming (creator of James Bond), and the husband of Celia Johnson, the actress, best remembered today as the heroine of David Lean's film, *Brief Encounter*.

Mary Keswick

Every year he used to arrive on August the tenth with various members of his family. Hardly out of the car – children would get the luggage out – he'd come up here to wait for his pigeons. He seldom shot one because there were so few, but he liked the peace and quiet. Dear old Pete.

Tony Keswick

When Peter first came to China he had just written *One's Company*. He came out to stay with us. I said, 'It's very important if you're going to see Chiang Kai Sheck to have a visiting card.' He asked me to get his name put into Chinese phonetically for this card, which I did – but as a practical joke the first one we gave him said in Chinese 'Silly Little Bugger'. So when he presented it they all looked down their noses. Phonetically, just a translation of sound, the nearest thing to the Chinese characters for Fleming – Fu Le Ming – actually means 'carver on heavenly stone' or 'lover of golden forests'. It's a nice memory and it's useful because sheep and cattle scratch on it. He was a very simple and really charming man; a very clever man, I think, intellectually.

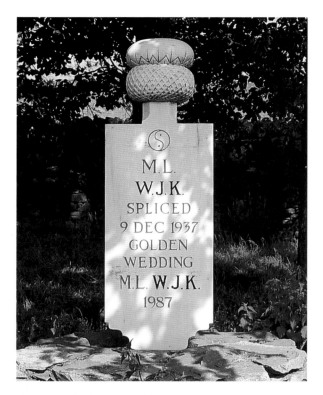

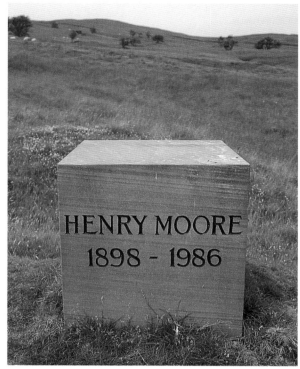

Tony & Mary Keswick memorial

Turkish widow's headstone, marble, inscribed:
'M.L. / W.J.K. / SPLICED / 9 DEC 1937 /
GOLDEN WEDDING / M.L. W.J.K. / 1987'

On a trip to Istanbul in the 1970s, Tony
Keswick was much taken with the 'widows'
stones' he saw in the cemeteries. Apparently
the 'turban'-topped stones were the traditional
entitlement of a widow in Turkey, a tradition
which still holds good today. He soon decided
that he would like one as a memorial stone for
himself and Mary Keswick at Glenkiln, and
left his friend Sir James Bowker (then the Brit-
ish Ambassador to Turkey) to fix it. This Sir
James managed to do after a good deal of dif-
ficulty, and a stone was shipped to Scotland.

The inscription is in red but on the death of
Tony Keswick his initials were painted black,
like the monogram on old Rolls Royces.*

Henry Moore memorial

A square block of sandstone quarried
and carved locally, inscribed: 'HENRY MOORE /
1898–1986'.

Tony Keswick originally placed a curling stone
on the top. He did not explain why, but it
seemed a fittingly poetic solution – Moore had
just been influenced by the shape of stones and
his sculpture tends more to rotundity than
angularity. Also, there was a suggestion of his
work starting on its journey with his death,
like a stone leaving the curler's hand. But in
Keswick's modest opinion, it was too much
about himself playing the artist and not
enough about Henry Moore; so he removed the
stone and left the block.

* The first Rolls Royce cars have the monogram in red. Following
the death of Charles Stewart Rolls, one 'R' was painted black; and
following the death of Sir Henry Royce, both 'R's were made black
in perpetuity.

Henry Moore died on 31 August 1986

Tony Keswick died on 16 February 1990

Requiescant in Pace